FRESH PAINT

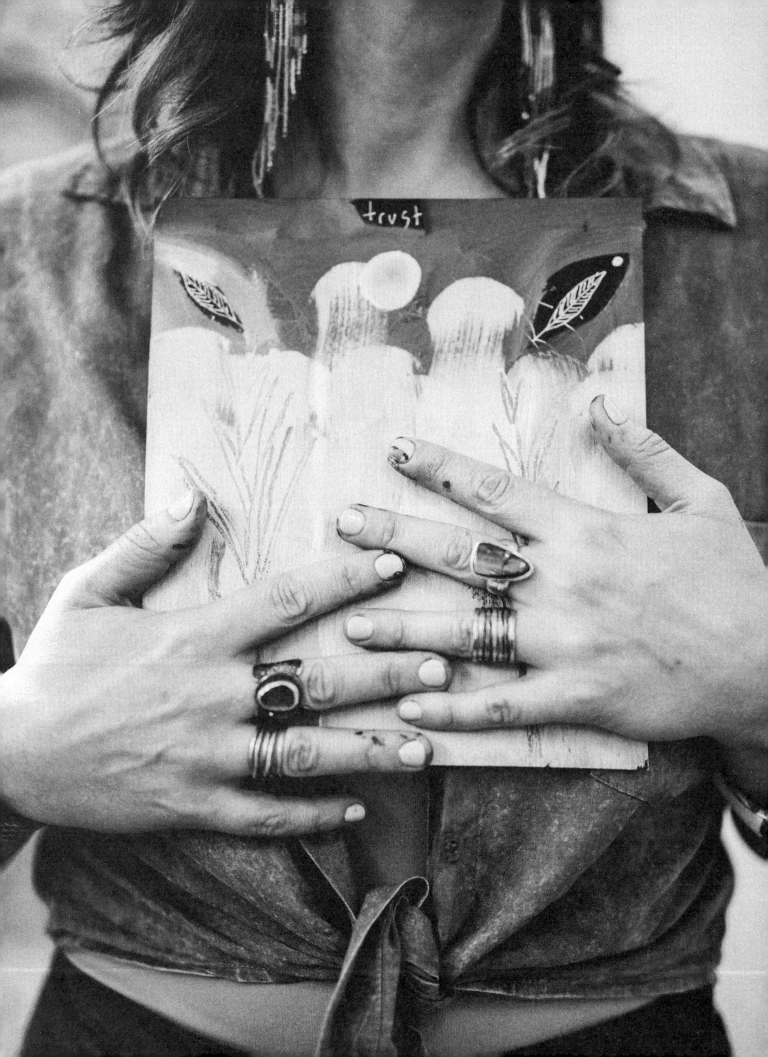

FLORA BOWLEY
& LYNZEE LYNX

FRESH PAINT

Discover Your Unique Creative Style
Through 100 Small Mixed-Media Paintings

Quarto Publishing Group USA Inc.
Text © 2021 Flora Bowley and Lynzee Lynx

First Published in 2021 by Quarry Books, an imprint of The Quarto Group,
100 Cummings Center, Suite 265-D, Beverly, MA 01915, USA.
T (978) 282-9590 F (978) 283-2742 QuartoKnows.com

Quarry Books titles are also available at discount for retail, wholesale, promotional, and bulk purchase. For details, contact the Special Sales Manager by email at specialsales@quarto.com or by mail at
The Quarto Group, Attn: Special Sales Manager, 100 Cummings Center,
 Suite 265-D, Beverly, MA 01915, USA.

10 9 8 7 6 5 4 3 2 1

ISBN: 978-0-7603-7068-1

Digital edition published in 2021
eISBN: 978-1-7603-7069-8

Library of Congress Cataloging-in-Publication Data

Names: Bowley, Flora S., author. | Lynx, Lynzee, author.
Title: Fresh paint : discover your unique creative style through 100 small
 mixed-media paintings / Flora Bowley, Lynzee Lynx.
Description: Beverly, MA : Quarry Books, 2021. | Includes index. | Summary:
 "Inspired by the authors' popular online course, Fresh Paint is a
 collection of lessons, prompts, and exercises that offer a deep dive
 into the practice of "finding your style" in the process of making 100
 small mixed-media paintings"-- Provided by publisher.
Identifiers: LCCN 2021016389 | ISBN 9780760370681 (trade paperback) | ISBN
 9780760370698 (ebook)
Subjects: LCSH: Mixed media painting--Technique.
Classification: LCC ND1505 .B675 2021 | DDC 751.4/9--dc23
LC record available at https://lccn.loc.gov/2021016389

Design and Page Layout: Kelley Galbreath
Photography: Anna Caitlin www.annacaitlinphotography.com

Printed in China

JANUARY 2022

To all the creative souls who seek to find
what only they are here to share.

CONTENTS

INTRODUCTION

WE'RE SO GLAD YOU DECIDED to join us for this potent adventure of discovering and developing your unique creative style.

We believe that cultivating an authentic creative voice translates into a more courageous, inspired, and world-changing way of living. We also believe this is a vital time for each of us to offer our personal and heartfelt stories and visions to the world.

Your interest in *being here* is so important, and we want to acknowledge you for that. In fact, you'll see that *Desire* is at the top of our list of "Eight Ingredients" that go into developing a unique artistic style, so you're right on track!

You may have noticed that there are two of us writing this book: Flora Bowley and Lynzee Lynx . . . that's us! We're both lifelong creatives, and we've been weaving our creative visions for the past ten years through collaborative painting, facilitating online and in-person workshops, and now coauthoring this book. We are also dear friends—the kind that feels more like chosen family.

After years of guiding hundreds of new and experienced painters through online courses and in-person workshops, we noticed a collective "readiness" from our students to create work that was more personal, unique, and true to them—a natural progression for most artists and makers.

However, we also noticed how difficult it seemed to actually *develop* this kind of distinct style, even though the *desire* for it was heartfelt and sincere. Perhaps you feel this way too?

Many of our students find themselves feeling overly influenced by other artists and not quite sure how to develop their own recognizable style within a sea of outside influences. They want to feel joyful, confident, and strong in their visual language, use of color, and applied techniques. Most importantly, they want to bring more of *themselves* to the working surface.

But, how exactly do you to get there?

This conundrum, along with our shared passion for authentic expression, provided the spark needed to create a radically new and potent curriculum for painters looking to find more integrity, depth, and originality in their work.

We presented the first iteration of this philosophy and practice in the *Fresh Paint E-Course*. Seeing our curriculum come to life and expressed through thousands of unique paintings and hearing about the breakthroughs our students experienced along the way demonstrated that this approach of developing a painting style really does *work*.

Inspired to see even more original style surfacing throughout our creative communities, we're so honored to be able to offer this body of work to you in book form. We truly hope what you find within these pages sets your artistic spirit free while setting you apart from the crowd. We know you have what it takes to infuse more meaning, integrity, and personality into everything you touch, and we're here to help you make that happen!

We also want you to know that we're personally dedicated to pushing our own boundaries as we continue to evolve as artists, and we look forward to walking this path right along with you.

Thank you so much for being here with us.

Love,
Flora & Lynx

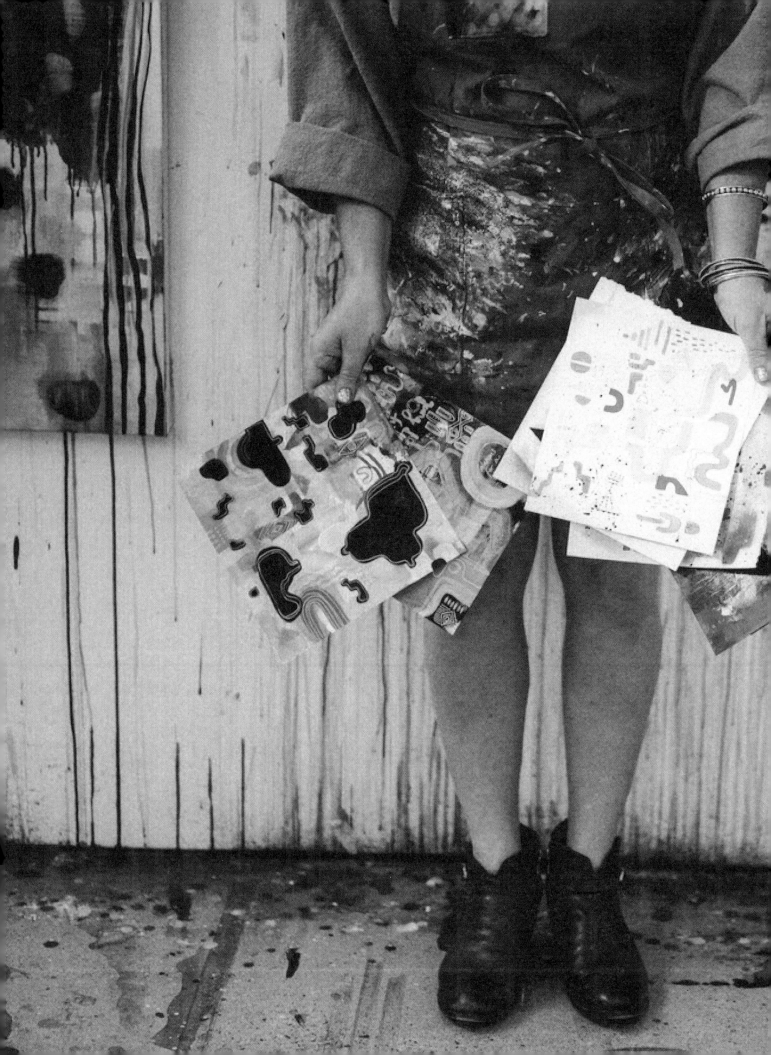

OUR PHILOSOPHY

AS YOU TAKE THE FIRST STEPS on your style-finding adventure, we want to begin by sharing a few big-picture concepts that will help lay the foundation for your journey ahead.

While the invitations within these pages are certainly not presented as a step-by-step manual, understanding how you will be spending your time and how you can most effectively move through the material is always helpful!

We can't wait to get started . . .

EIGHT INGREDIENTS FOR FINDING YOUR STYLE

We believe there are eight key ingredients needed in order to discover and develop a personal creative style. These ingredients are: **Desire**, **Self-Inquiry**, **Trust**, **Awareness**, **Expansion**, **Exploration**, **Gentleness**, and **Dedication**. Below, we've expanded upon why each of these ingredients is so vital to this process.

1. Desire

Having a clear desire to explore or make a change is often the first step on any journey. This kind of sincere motivation serves as potent fuel for the quest, and it also helps you stay the course. We imagine if you're reading this book, you already have the desire to find your unique style, so you're off to a great start!

2. Self-Inquiry

If you want to invite more of *you* into your creative process, your life experiences, cultural lineage, relationships, passions, and memories create a fertile ground where your personal style has already been developing and growing throughout your entire life.

3. Trust

Fostering the courage to listen to your intuition is a foundational practice when it comes to seeking your own artistic style. From there, learning to *trust* what you see, hear, and feel in order to bring this information to life in new and meaningful ways is the next step.

4. Awareness

Moving through your day-to-day life with a keen awareness of what draws you in and lights you up not only makes the world around you feel more alive, but it also connects you to the present moment and to your creative spirit each and every day.

5. Expansion

Continually evolving and growing in different ways, learning from new teachers, pushing your boundaries, and exploring techniques and materials that are unfamiliar create more opportunities for something truly unique to emerge in your art-making practice.

6. Exploration

Giving yourself the time and space to explore and try things on in a way that is curiosity-driven, not outcome-driven, is critical when it comes to developing a unique artistic style. We believe creating one hundred paintings and considering them "studies" is a great way to set yourself up for a world of exploration and success.

7. Gentleness

If you've engaged in the creative process, you've probably gotten to know your inner critic. Whether it's loud and obnoxious or soft and persistent, negative self-talk often gets in the way of freedom, and sometimes it even makes you want to quit. This is why cultivating a gentle and compassionate inner voice helps you stay present, even in the tough moments.

8. Dedication

Although it's easy to want to speed right to the finish line, discovering and developing a unique artistic style is a life-long journey that requires dedication and persistence. You *get* to do this work!

THREE AREAS
OF PRACTICE

With the *Eight Ingredients* serving as the foundation for our style-finding adventures, let's explore the three main areas of practice that each ingredient falls into. You can think of these as the three ways you will spend your time as you develop your artistic style: *Internal Exploration*, *External Exploration*, and *Hands-On Art-Making Practice*.

There are many ways to engage in each practice, and we wholeheartedly encourage you to branch out and add to our repertoire of explorations as inspiration strikes. In other words, do YOU. That's what this book is all about!

Here are some examples of different ways you might explore each area of practice:

Internal Exploration: Meditation, visualization, breathwork, mindful movement, learning about your ancestry, inner reflection, writing, remembering your lived experiences, paying attention to and feeling your emotions, and unplugging.

External Exploration: Slowing down to notice what's around you, seeing the world with "the eyes of an artist," paying attention to *all* your senses, sketching, taking photos, color collecting, reading, gathering and recording information, spending time with inspiring people, and going on artist dates.

YOUR UNIQUE STYLE

Hands-On Art-Making Practice: Prioritizing time and physical space to create, showing up to your practice, continuing to explore new mediums, engaging in curiosity-led experimentations, remembering to play, "studying" what feels interesting, letting go of perfection, being courageous and open to change, seeking supportive community, and being accountable.

HOW TO USE THIS BOOK

Before we break out the paints, we want to share some helpful tips and guidelines about how to move through this process and get the most from this book.

We understand many art books and courses offer a clear, start-to-finish set of instructions in order to create a desired and similar outcome. While this can be a great way to develop specific skills, the purpose of *this* book is quite different.

It's a Buffet!

Our intention here is to offer an inspiring and well thought-out framework that allows you to feel both lovingly supported and wildly free to flow within it. In other words, we're not going to tell you exactly what to do. Instead, we're going to offer you an eclectic and inspiring buffet of prompts, exercises, and philosophies for you to consider. Each item on the buffet can be explored in infinite ways, and our hope is that they serve as potent jumping-off points as you make your own unique discoveries along the way.

It's likely that some parts of this book will light you up and draw you in deeper, while others might not feel as interesting. That's perfectly okay. Noticing what you find most captivating is an important part of finding your own way, and we'll be cheering you on all the way.

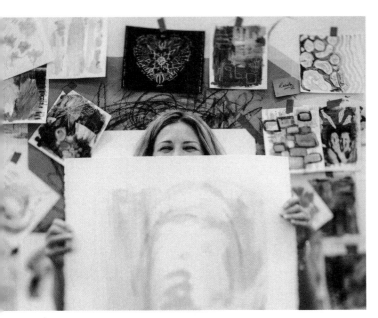 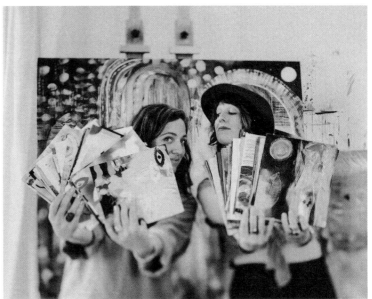

Why One Hundred Paintings?

This entire book is based around the practice of creating one hundred small paintings as a way to connect more deeply to yourself and the world around you, to trust in your own personal inclinations and preferences, and most importantly, to "do the work." Chapters 3 through 7 will lead you on this journey.

There are a few reasons we've designed this curriculum around the goal of painting one hundred small paintings. First, we think working on little pieces of paper is much less scary and precious than working on one or two big canvases. We also believe the only way to develop a unique painting style is to do a *whole lot* of work, and one hundred paintings is certainly a lot of work! We also love a solid, tangible goal to keep us going.

That said, if painting one hundred paintings feels stressful to you, start with a number that feels calming for your nervous system—maybe that's fifteen, fifty, or seventy-five. Whatever magic number you decide on is the one for you. Remember, the number is simply a goal to keep you moving forward and engaged in the practice, and you can always keep adding in more paper as you go.

Find a pace that works for you and remember: The most important thing is to stay open, curious, and inspired—not overwhelmed.

"Studies" Versus "Little Masterpieces"

Starting now, we invite you to start thinking of your one hundred pieces of paper as "studies" versus "little masterpieces." Artists have historically used sketchbooks and studies to prepare themselves for more in-depth works of art—and for good reason.

Studies provide a forgiving place to play, try things out, and experiment without the pressure of having to create something serious, perfect, or totally resolved. Whether they're quick sketches or more involved explorations of color or composition, what's important is that your studies inspire a feeling of freedom and curiosity.

At the end of the book, we'll offer some suggestions around what you might do with all those little paintings. We'll also talk about how to translate what you learned into larger work if that's of interest.

Remember, this process is about discovering and developing a unique style, and that takes time. You won't love everything you create, and that's actually important. It means you're taking risks and trying new things. Through this kind of brave experimentation, you'll learn what works for you and what doesn't. From there, you can hold onto the gems and let the rest go.

Just keep going.

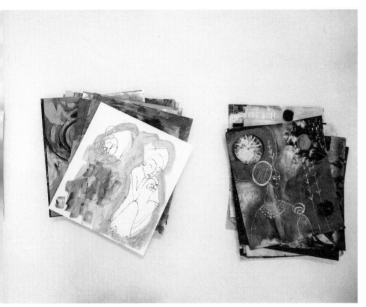

Circling Back
(This Is Not a Linear Process)

Each of the chapters in this book presents different philosophies, art exercises, writing inquiries, and prompts to support your style development. Again, we like to think of these invitations as a buffet of options for you to explore.

As you explore the buffet, we encourage you to begin new paintings on fresh papers as you feel inspired, while also circling back to add more layers to works-in-progress as your repertoire of ideas broadens.

For example, you might begin a painting by drawing things you love in your home. Later on, you might choose to do a color study on that very same painting. This kind of layering will allow you to experiment with different ideas without needing to "finish" a painting in one sitting. There's plenty of time for that, and we'll give you some finishing tips at the end.

As you move through the book, we suggest you keep your papers in three piles:

1 Blank papers not yet started

2 Works-in-progress

3 Finished studies

While this nonlinear way of creating might feel unfamiliar or even uncomfortable at times, we hope you'll find this layered and intuitive approach to painting to be forgiving and full of freedom and surprises. We also hope what we're presenting here offers a whole new way of thinking about your creative practice that will set you up for a lifetime of success and exploration.

Remember, anything is possible, and this is just the beginning.

Creating an Inspiration Archive

In addition to your one hundred paintings (a.k.a studies), we also suggest that you create an Inspiration Archive to keep track of all your discoveries in one convenient place. We like to use a three-ring binder for this, but a dedicated drawer, basket, or box will also do the trick.

Of course, you're always welcome to explore the exercises directly onto your one hundred paintings, but there may be times when you want to reference a drawing or your writing inquiries later on. This is a perfect time to "archive" these inspirations in your binder. You can also keep any collected mixed media ephemera (short-term, paper-based memorabilia, such as post cards, letters, ticket stubs, old newspaper clippings, magazine clippings, or photos) in your Inspiration Archive.

2

SETTING THE STAGE
TO CREATE

PREPARING YOUR SPACE and gathering your materials can be a fun and exciting time to set the stage for your art-making adventures.

The exercises presented in this book do not require a large or fancy studio space or expensive materials. In fact, we believe necessity is the mother of invention, so working with limited space and the supplies you have on hand can actually invite even more unique-to-you discoveries along the way.

Working with what you have is also a great way to intimately get to know *those* materials and encourages you to add in new supplies in a more mindful way as you are ready.

As for your "studio," there are many ways to create inviting and functional art-making spaces just about anywhere with just a few thoughtful touches. Your kitchen table is perfect!

What's most important is that your materials and space work for *you*.

PREPARING YOUR WORKSPACE

Some of you might have a permanent space for making art, while others will need to put your art supplies away after each session. Either way is just fine, but if you don't have a permanent situation, we suggest having some kind of "art cart" to organize your mobile studio. This can be as simple as a cardboard box or as fancy as a cart with various levels and wheels for easy moving.

Since painting is often pretty messy, we also suggest covering your work surface. You can do this with butcher paper, newspaper, or even large sheets of watercolor paperthat you later cut up into smaller painting starters.

Now, let's talk about the vibe in yourart-making space. Ideally, this is a place you want to be because it feels so positive, comfortable, and nourishing to your creative spirit. There are many ways to create a space like this, and this is a greatme to tap into what brings *you* joy and comfort.

You might consider building an intentional altar or placing meaningful objects that remind you of what's important to you in your space. Candles, music, plants, photos, fabrics, and inspiring quotes can also make your space feel cozy, inviting, and personal to you.

It's also important to make your space functional and body friendly. You might be most comfortable sitting at a table in your favorite chair, or you might want to spread out on the floor. We personally love to mix it up between sitting at a table and standing with our paintings either taped or pinned on a wall. You could even cut the legs off an old table and sit on the floor *while* working on a table at the same time. We encourage you to get creative with your creative space!

Lastly, be sure you have adequate lighting so you can see what you're creating. Your lighting setup doesn't need to be fancy. Some basic clip lights from the hardware store can brighten up an otherwise dim space, and a few strands of twinkle lights can bring a little magic into the room as well.

Like all creative processes, your art-making space is something that can shift and change over time, and in fact, this is a great way to breathe fresh energy into the space and your process. Have fun with it!

GATHERING YOUR MATERIALS

One of the best ways to develop a style that is unique to you is to explore a wide variety of materials in a lot of different ways.

Below, you'll find a list of the materials we mention throughout the book, but it's absolutely okay if you don't have everything on this list. The most important things to have are a basic set of acrylic paints, watercolor paper, and your favorite brushes.

All the exercises can be modified to work with what you have, and you can always add in more materials as you go . . . follow your artistic cravings and trust your curiosities.

- **100 pieces of paper (or however many you wish be begin with)** cut into squares, approximately 9 x 9 inches (23 x 23 cm) (See "Tips for Cutting Your Paper" on page 25.)

- **Acrylic paints** in a variety of **colors**, ideally including both fluid and heavy bodied paints—at a minimum, be sure to have **yellow**, **red**, **blue**, **black**, and **white**.

- A variety of **paint brushes** and **foam brushes**

- A collection of pens and markers such as **permanent markers**, **colored paint pens**, **pigment-based ink pens**, **gel ink pens**, and any other favorite drawing tools you love to work with

- Potatoes (or other vegetables) and a knife for carving them

- **Rubber carving block** and a **linoleum carving set**

- **Manila envelopes** and a **utility knife**

- **Spray paint** or **spray ink**

- **Carbon paper** or **graphite paper**

- **Magazines** or **collage papers**

- **Acrylic gel medium** for adding collage materials into paintings

- Any other paints or mixed-media materials you want to explore—it's all welcome here!

TIPS FOR CUTTING YOUR PAPER

We suggest buying large sheets of 140 lb (300 gsm), or heavier, water-color paper and cutting them down into similar sizes such as 8 x 8 inches (20.5 x 20.5 cm), 9 x 9 inches (23 x 23 cm), or 10 x 10 inches (25.5 x 25.5 cm). The size and shape of your paper is really up to you. They also don't need to match. Again, it's your call.

There are a few ways to cut your paper. If you have access to a paper cutter, this will make the job quick and easy. We recommend premeasuring your paper and marking the measurements with pencil marks to make the cutting process easy. You can also use a box cutter or a utility knife together with a straightedge tool or a metal ruler. Good old-fashioned scissors are also an option, but this will take some time and might not give you the straightest lines. It's also worth asking your local office supply store if they are able to do the cutting for you. Another option is to purchase precut watercolor paper in pads. Some common sizes that will work well for this process are 7 x 10 inches (18 x 25.5 cm) or 9 x 12 inches (23 x 30.5 cm), but again, you're welcome to work on any size that works for you.

3

GATHERING INSPIRATION FROM YOUR INTERNAL LANDSCAPE

YOUR INTERNAL LANDSCAPE is a vast and limitless space where your personal and familial histories mix with your current passions and interests, along with the many preferences and personal tastes you have developed and honed over time.

An honest exploration of this rich landscape is a sort of personal treasure hunt full of precious gifts to discover and integrate over time. By getting quiet, asking questions, and connecting the dots along the way, little clues from your past will help to inform your future, and your personal art-making style and "visual language" will begin to emerge in real time.

This kind of personal introspection is important on a number of levels, as it will nourish your art-making practice as well as your whole life.

THE WISDOM WITHIN YOUR SKIN

In a time when information and imagery from other people's art is so readily available at our fingertips, we believe mindfully sourcing inspiration from within our own hearts and authentic lived experience is a crucial part of finding a unique voice. That's exactly why we believe turning inward is a perfect place to begin your style-seeking journey.

Throughout this chapter, we'll take the time to remember who we've always been and what we've chosen, again and again, as a compelling way to notice patterns of style that are already rooted deep within. We'll also explore our cultural roots, families of origin, and our "chosen families" as a way to deepen our connection to our personal history.

As you spend time with this chapter, we encourage you to limit your exposure to other people's artwork in order to reduce the static of outside influence as you connect more deeply to your own personal experience. Overexposure to other people's ideas can easily drown out the subtle soft voice of our own intuition, and we really want you to experience the clarity of your *own* inner voice.

We'll have plenty of time to explore how to honorably integrate outside inspiration in Chapter 7, but for now, let's sink into all the wisdom that's right there within your skin. There is so much to discover, and you have exactly what you need to find it.

We believe just as your genetic code is one hundred percent unique, your artwork can be a reflection of this scientific truth. In this foray into the world within, we hope that you'll discover an endless source of inspiration that is full of the precise heart, soul, and story that makes you, *YOU.*

We know it's not about *if* you will find it, it's about *when.*

A SIMPLE MEDITATION

We'd like to set the stage for this chapter by offering a simple meditation because we believe consciously quieting the mind is an essential part of connecting to our inner landscape. We hope this simple practice becomes a regular part of your art-making ritual. As always, do it *your way*.

It's easy to move right from the busyness of life into your art-making practices with little pause in between. However, getting in the habit of slowing down and taking some deep centering breaths before you create opens up channels of intuition that can lead to more authentic and connected creativity. A simple meditation practice can also give the swirling details of the day a place to settle and drop away, making more space for your creative vision to flow through.

To begin, find a comfortable place to sit, either on the floor or in a chair. You're also welcome to lie on your back if that's more comfortable. Place your hands mindfully on your lap, by your sides, or place your palms facedown on your belly or heart. Close your eyes if you wish or find a place to rest your gaze.

Begin by taking a few deep breaths in and out. Let go of needing to control your breath and just let it flow, each breath linked to the next. Soften any tension you're able to release with your exhales.

Lengthen your spine with your inhales. Relax your belly, the space between your eyes, your jaw, your throat, and the palms of your hands.

Keep breathing.

If it helps you to maintain concentration, feel free to count as you inhale for a few seconds and exhale for the same number of counts. You're also welcome to repeat words such as: *"I breathe IN peace"* and *"I breathe OUT fear"* or whatever words feel most supportive to you and this practice of settling in and opening up.

You can use this simple meditation practice anytime, but we especially recommend it in the mornings, evenings, before your art-making sessions, or whenever you're feeling disconnected from your truth and center. Can you commit to performing this practice once a day for the next week or before you begin to paint? Even just a few minutes of mindful breathing can be so potent.

SOURCING IMAGERY FROM YOUR MEDITATION

We find that unique and personal images can sometimes emerge in our mind's eye when we sit quietly and focus on our breath. If you're curious to explore this path with more intention, we're happy to share some ideas and suggestions below.

We find that covering our closed eyes with a cloth helps to block out ambient light and allows the images that emerge behind our eyelids to become even brighter and easier to discern. You may a folded bandana, headband, scarf, or any kind of cloth you have to block the light from your eyes if that's comfortable.

In addition to focusing on your breath to become more present, you can also ask the Universe (or whatever source you feel connected to) to show you imagery before you begin. You may ask specific questions such as, "What do I need to see today?" If nothing emerges naturally, simply choose a shape or image to focus on and see if it wants to morph into something else.

If images, shapes, or ideas arise in your meditation, feel free to jot down some sketches of what you saw when you open your eyes. This is your personally sourced imagery direct from your imagination!

EXPLORING YOUR ANCESTRAL AND CULTURAL HISTORY THROUGH MIXED MEDIA EPHEMERA

There's a rich world of imagery and inspiration that can be sourced through our lineages: both cultural and ancestral. We find that working with this kind of personal ephemera can add not only a layer of beauty but also meaning to our artwork, and we're excited for you to explore this in your own work.

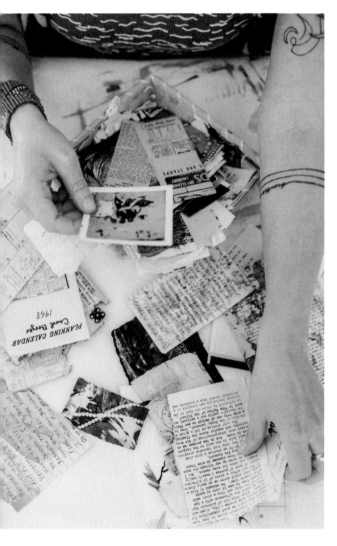

If you've saved bits of papers from travels, letters from loved ones, or photos from times gone by, this is all great material. Some other things you might incorporate are: found objects, song lyrics, religious or spiritual passages, inspiring quotes, magazine clippings, scraps of fabric, poems, words written in your ancestral language(s), and personal symbols. These are all precious materials that can help to inform who you are as an artist and what your art looks like and evokes. *Please note, if you don't want to use original photos or papers, you can use photocopies instead.*

A Note on Cultural Appropriation and Cultural Appreciation

Our human history is vast and varied and conversations surrounding colonialism and power dynamics reveal a long history of abuses and unfair distribution of wealth and freedom.

With that knowledge, we believe it's incredibly vital as visual artists to take as much interest in the origins of our inspiration as we take in our personal art-making processes.

As you seek out personal imagery and material to work with, consider the topic of cultural appropriation. A simple definition of cultural

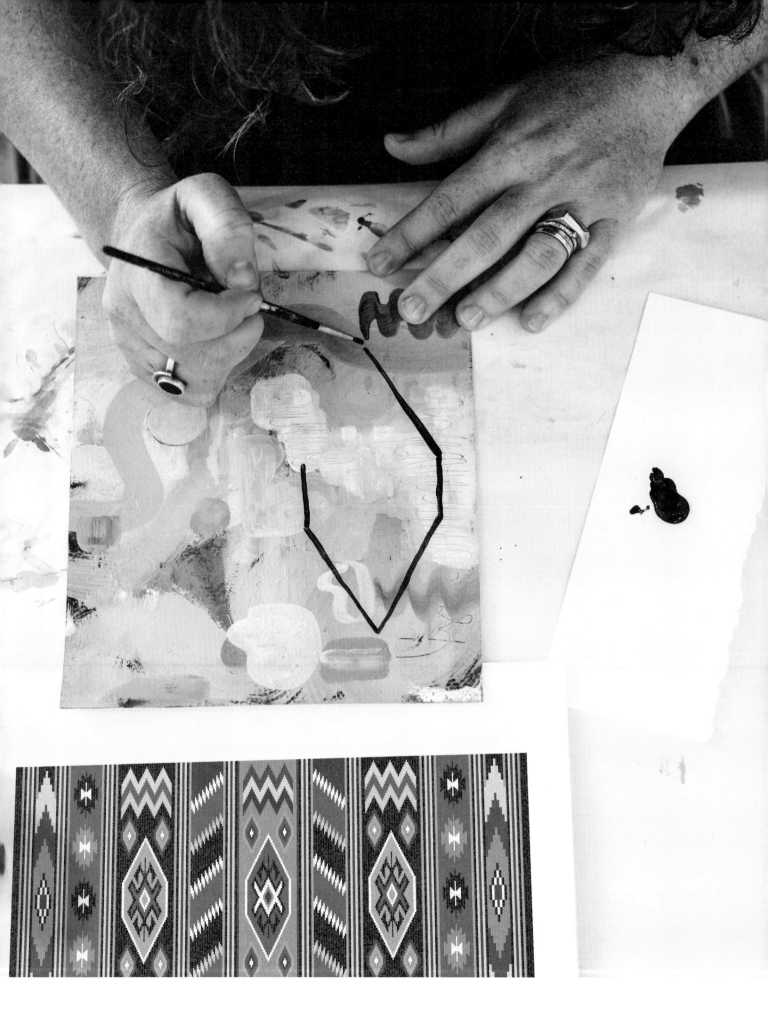

appropriation is: *The unacknowledged or inappropriate adoption of the customs, practices, ideas, etc. of one people or society by members of another and typically more dominant people or society.*

To avoid appropriating, we encourage you to look into the origins of symbols or imagery you feel drawn to use in order to understand where they come from. Next, consider if you stand to benefit from the use of that imagery by making money, gaining status, or looking good. If so, understand that it's not okay to borrow, take, or derive direct inspiration from groups or communities that you do not belong to in some way.

Instead (and this is the exciting part), we encourage you to get extra curious about your own cultural identity and lineage and the types of symbols, imagery, and inspiration that are available to explore there. If possible, engage in conversations with your family about meaningful traditions and stories, dig into family tree research, or take a DNA test to gain an even deeper understanding of your ancestry. Also consider what kinds of groups or communities you belong to now and what kind of cultures you've created together.

We're excited to see what you discover and how you might incorporate it into your art-making practice. Who knows? A signature style might be waiting to emerge from what you find!

We also want to touch on the idea of cultural *appreciation*. A simple definition of cultural appreciation is: *When someone seeks to understand and learn about another culture in an effort to broaden their perspective and connect with others cross-culturally.* In our eyes, it's fair game to love, admire, witness, and appreciate artistic expression that has been generously shared with the world no matter

who made it. However, we must learn to appreciate things without *taking* them.

In chapter seven, we'll explore how to mindfully glean inspiration from other artists, and you'll find that many of those principles can also be applied to this conversation. We understand it can be tricky territory to know what is okay to use and in what ways, but we believe broadening our awareness and becoming more mindful are essential places to start. We also believe that narrowing the field of what is available inevitably forces us to be even more innovative and creative, so let the challenge be part of your inspiration!

Incorporating Personal Material into Your Artwork

Once you have gathered up an archive of meaningful bits and pieces from your life, there are infinite ways to use it in order to infuse more meaning into your one hundred paintings. Here are a few ideas to get you started:

- Add papers directly into the layers of your paintings. Use a utility knife to cut portions of papers to yield an exact silhouette. Tear papers to create a rougher and more natural look. Stitch your items using a needle and thread directly onto watercolor paper. Use an acrylic glazing medium to add ephemera to your paper.

- Further affect the look and feel of the items and make them even more personal by burning, scratching, soaking, dyeing, ripping, marking, or otherwise distressing or changing any of the materials you choose to incorporate.

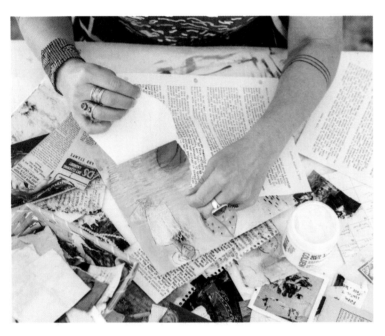

friendly, we suggest seeking out materials that you *already* have that hold personal meaning versus buying premade "collage materials" from an art supply store. Remember, this is a great time to pull out that old box of letters, photos, or documents that you've been hanging onto and upcycle them into your artwork—a beautiful way to feature, honor, and preserve their significance. (As we mentioned previously, if you don't feel comfortable using the originals, you can always make photocopies instead.)

This is also a great time to consider what other art mediums might have significance to you or your family. For example, Lynx grew up working in her family's bead shop and has been making beaded jewelry since she was eleven years old. It was a natural progression for her to combine two long-standing passions: beading and painting.

Flora had a similar but different experience when she realized she could incorporate a box of her mom's personal handwritten papers and letters into her artwork. Weaving these treasures into her paintings became a meaningful way to process and honor her mother's life.

When it comes to adding mixed media into your paintings, there's really no right or wrong way to proceed. You can begin a fresh painting with a layer of ephemera and layer paint on top of that. You can also add bits of mixed media along the way at any stage of your layering process. Allow the placement and timing to be an organic and intuitive process and stay open to how things want to evolve as you go.

- Use your own handwriting to add song lyrics, poems, quotes, or teachings into the layers of your paintings.

- Draw inspiring shapes or images that you found in your collected materials and add these drawings to your paintings at any time.

- To add paper, cover one side of the paper with gel medium, press it firmly onto your watercolor paper to smooth out any bumps, and finish with another layer of gel medium on top. Feel free to mix in paint as well.

For the purpose of creating art that is truly unique and meaningful to you and also ecologically

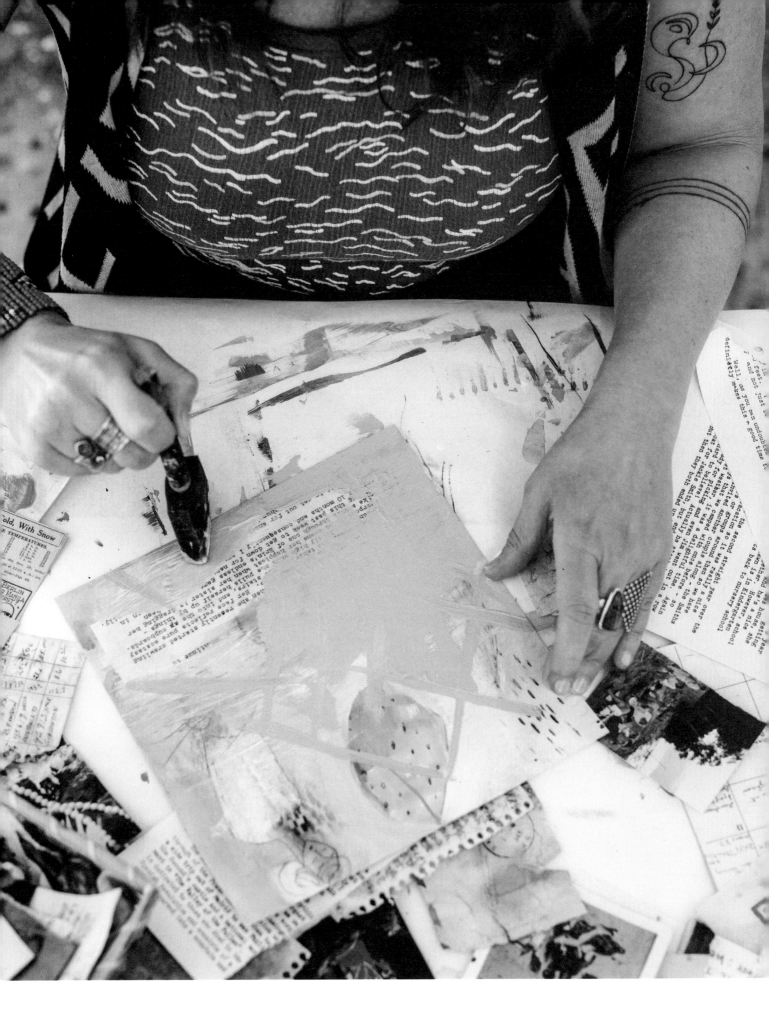

WRITING INQUIRY:
Your Truths

In a freeform style to avoid overthinking, finish the following sentences and allow yourself to keep writing more for each prompt if you feel inspired. Think of them as a jumping-off point and go from there. Remember, this is just for you, so don't hold back. When you're done, look back and circle any words or phrases that stand out and notice any themes you see emerging. *Notice what feels inspiring. Notice what feels tender. What did this exercise bring up for you?*

I was born in the year _____.

So, I grew up in the time of _____.

Growing up, I was surrounded by _____.

I've always loved _____.

Something that comes naturally to me is _____.

My family is from _____.

Traditionally, my family _____ _____.

My chosen family is _____.

My greatest teachers are _____ _____.

I surround myself with _____.

The books that really changed my life are _____.

My greatest dream right now is to _____ _____.

Four words I live by are _____, _____, _____, and _____.

DRAWING IMPROVISATION

One of the most impactful ways to create a unique visual style is to develop your own visual language or way of expressing your ideas through personal shapes and imagery.

We believe one of the best ways to do this is through improvising or "riffing" on one idea in many different ways. This kind of improvisation allows you to let go of formulas, try on new ways of doing things, and explore a subject or shape in more depth.

Start by using simple lines to divide a sheet of paper into at least four squares, creating a grid. You can do this on your painting papers or in a sketchbook.

Next, choose a word or idea that stands out to you from either the Writing Inquiry, the Meditation, or your Mixed-Media Ephemera. For example, Flora might choose her birthplace of Wisconsin and Lynx might choose Turkish Textiles because that's where her family of origin is from. You can also choose a simple shape to riff with like you see pictured below.

In each box, improvise different ways you might visually express something about the word or idea you chose. Repeat this exercise as many times as you'd like with different subjects from your writing.

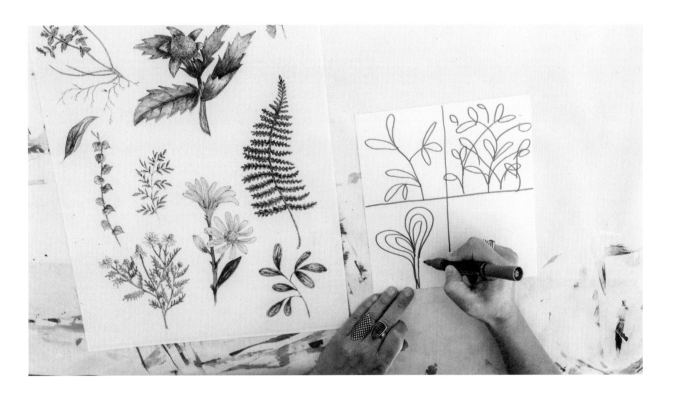

LIGHT ON DARK MANDALA

Mandala is a Sanskrit word that translates to mean "circle."
Traditionally practiced in Hindu and Buddhist cultural arts, mandalas are thought to represent the cosmos and our orientation *within* the cosmos. Jungian psychology also employs the mandala to assist in the "reunification of the self."

In this book, we respectfully borrow the word mandala to invoke the creation of a symmetrical circular image, while inviting a spontaneous way of creating and honoring our *own* place within the cosmos.

In this exercise, we'll also explore the use of light colors on a dark surface as a way to explore contrast.

To begin, use gesso or black paint to cover at least one of your painting papers. When it's dry, use a light-colored oil pastel, pencil, gel ink pen, and/or paint pen and write the four words you live by from the Writing Inquiry on the four edges of your paper—one on each edge. Let these words be the guardians of the four edges of this piece.

To begin your mandala, choose one mark, shape, or word as the center point and place that in the middle of your paper. Next, continue to create marks, designs, and shapes in a circular way, radiating or rippling out concentrically from the center point.

Allow this art-making exercise to be a *presence practice* as each mark informs the next—one small step at a time.

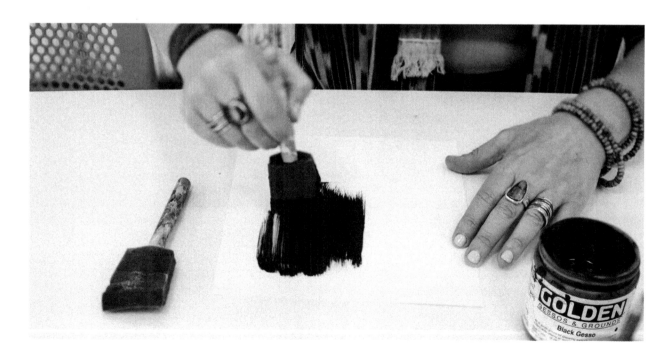

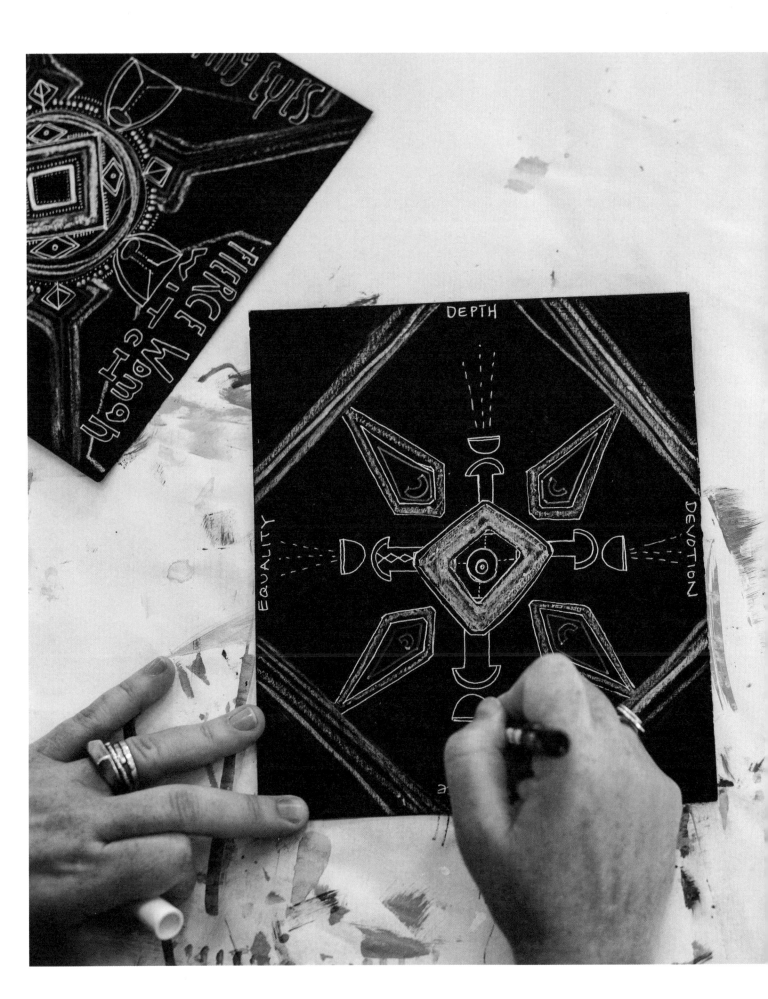

INTEGRATE AND CREATE

At the end of each of the following chapters, you'll find an "Integrate and Create" section.

Remember, there is no formula here for how to move forward. Simply use what you've explored within the chapter as inspiration as you continue to begin new paintings and/or add layers to works in progress. We'll also include some "Jumping-Off Points" for inspiration.

This chapter was all about exploring your inner landscape, so this is a great time to consider what kind of personal visual language is starting to emerge from the meditation, writing, drawing, and collage exercises.

Remember, how you choose to integrate what you've gleaned from this chapter is totally up to you. Take what feels the most inspiring and use that as a starting point. Allow the rest to unfold as you go. We've only just begun!

Jumping-Off Points

If you're feeling unsure about how to begin, here are a few prompts to get you going:

- Incorporate any shapes or images you discovered through your Meditation practice.

- Paint some of your cut watercolor papers either with black gesso or another very dark color to begin new paintings with a dark background, working light onto dark.

- Play with more collage from your family history or personal archives of papers and photos. Try beginning a painting with a full layer of collage.

- Create more mandalas or use elements from your mandalas in your paintings.

- Continue to translate the information you unearthed through the Writing Inquiry into a visual language and use the shapes and motifs in your paintings.

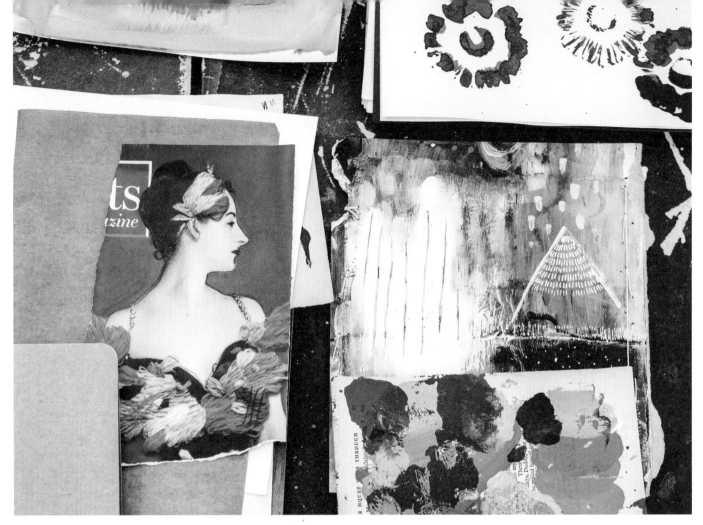

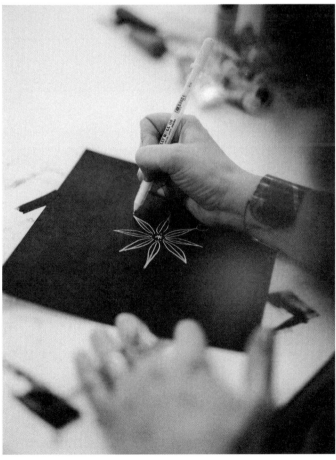

STUDENT GALLERY

Gathering Inspiration from Your Internal Landscape

This is a sampling of paintings completed by *Fresh Paint E-Course* participants.

TOP ROW, FROM LEFT:
- *Antje Zaremba*
- *Amber Walker*
- *Katina Edwards*

BOTTOM ROW, FROM LEFT:
- *Allyson Gunnell*
- *Shawna Pechanec*
- *Mathilde Berry*

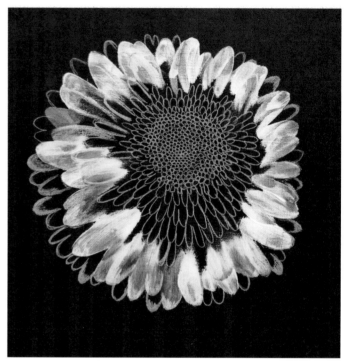

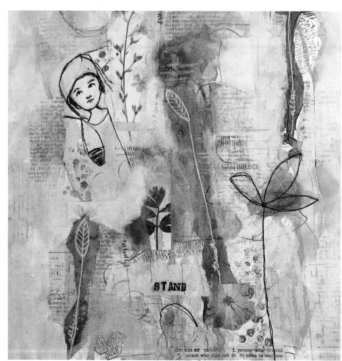

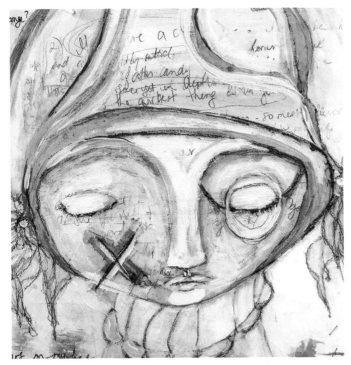

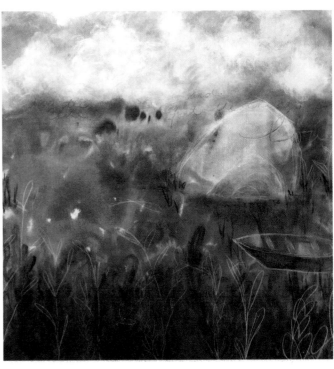

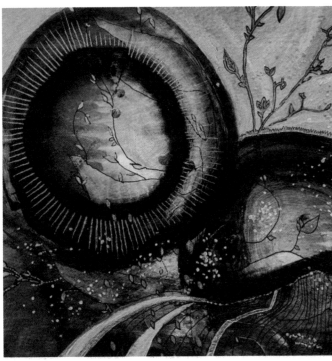

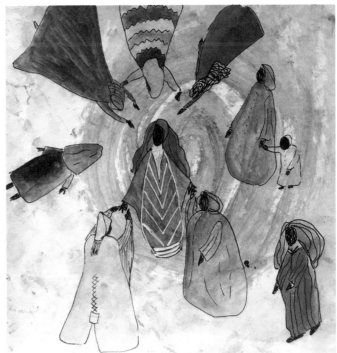

4

GATHERING INSPIRATION FROM YOUR EXTERNAL LANDSCAPE

IN THE LAST CHAPTER, we invited you to soulfully explore your internal landscape as a way to remember where you've come from, what has always been true for you, and what is stirring in your heart and imagination right now.

This chapter invites you to turn your *lens of noticing* outward as you find unique ways to synthesize the world around you.

While it's easy to breeze through our busy days without noticing much at all, we hope this chapter reminds you of the infinite sources of inspiration just waiting to be touched, seen, and experienced when we simply choose to tune in.

Can you remember a time when you slowed down long enough to drink in the softly shifting colors of a sunset or listened to the intricate soundscape of a favorite song, or felt the weight of the air on your skin? If so, you understand the depth of aliveness that's possible inside of every moment.

Creatively synthesizing this information is what this chapter is all about.

INSPIRATION GATHERING

There are so many ways to gather inspiration from the world around you, and we're happy to share some of our favorite, most effective approaches with you here. We think of this as filling our basket of inspiration, and it's a process that thankfully never ends.

We find great joy in this journey and believe it's our job as artists to consciously slow down, notice, and collect inspiration from our daily experiences—a practice artists have been participating in for hundreds of years.

As you explore the different exercises in this chapter, the most important thing is to stay connected to what feels most genuinely interesting to *you*. Your unique preferences are what set you apart from everyone else, and we're here to help you take that information and translate it into your creative expression.

It's also important to consistently collect ideas from many different sources. From there, there are countless ways to weave what you've collected into something that's all your own.

Okay, let's start gathering!

DRAWING EXERCISES:
Nondominant Hand, Blind Contour, and Shadow Drawings

Artists often carry sketchbooks to gather inspiration and record the world around them, and we believe this practice is a powerful way to support the development of a personal style.

Intuitive Wandering

If you're not sure where to start your drawing adventures, we recommend something we call *Intuitive Wandering*. You can play with this in your home, on a walk around your neighborhood, or anywhere you feel inspired to explore with your sketchbook.

Intuitive Wandering simply means taking a moment to check in with where your body wants to go rather than allowing your mind and habits to lead the way. If you're walking around the neighborhood and you get to an intersection, take a moment to pause. Place your hands on your heart or belly, close your eyes if that's comfortable, and notice if your body feels pulled to the right, left, forward, or back. Almost always, our bodies know exactly where they want to go!

Even if you don't fancy yourself a skilled drawer, the very act of noticing what catches your eye and taking the time to translate what you see in your own unique way connects you to your personal sensibilities and preferences. In this way, drawing can be used as a way to archive inspiration from your day-to-day life for future reference. If you want to skip the sketchbook, you can also draw from life straight onto your watercolor papers.

Below, you'll find some simple drawing practices to get you going, but it's important to stay open to the magic of the moment and what feels inspiring along the way. Embrace what comes naturally and what feels easy. Let go of perfection and remember *your* way is the right way. Play with different drawing tools and do many quick sketches without the need for them to be "right," "pretty," or "usable."

Most importantly, have fun with it.

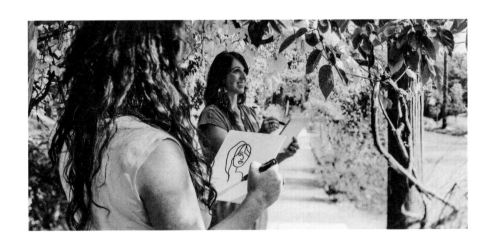

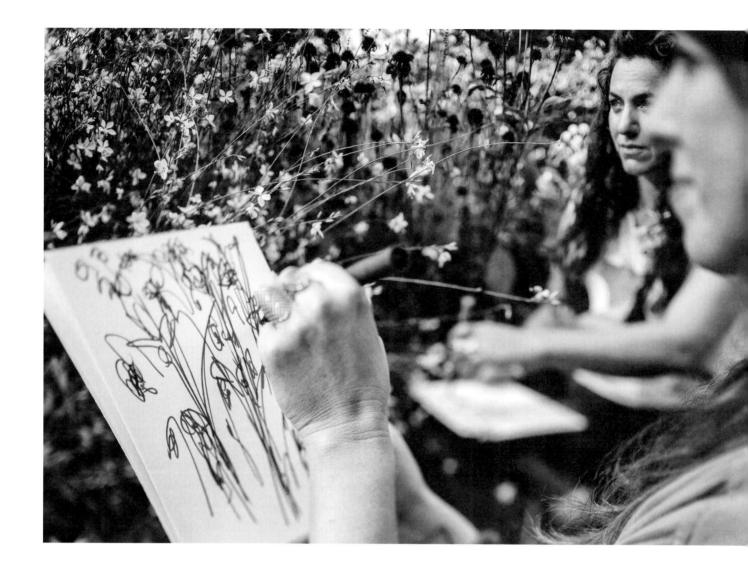

EXERCISE 1:
Nondominant Hand

Drawing with your nondominant hand is a great way to explore a looser, freer, and potentially more *you* way of creating. Letting your less practiced hand take the lead might feel awkward at first, but this is part of what's so exciting about this way of drawing. By releasing control and your habitual ways of creating, you'll instantly discover fresh energy in your lines and shapes.

Start by drawing something simple like a leaf, an item in your home, or an abstract shape and work your way towards more complex compositions as your nondominant hand gets a little practice. Play with drawing fast and then slowing it way down. Explore going big and letting the lines go off the edges of your paper and then switch to smaller, more detailed work.

Extra Challenge: *Try drawing with both your dominant and nondominant hand at the same time.*

EXERCISE 2:
Blind Contour

Blind contour drawing is another wonderful way of letting go of perfectionism and embracing the funky and spontaneous lines that emerge naturally when you stop looking back and forth between your paper and your subject matter.

Start by deciding what you'd like to draw, such as a flower, a friend's portrait, or a scene out your window. Without looking at your paper *at all*, draw your subject with one continuous line, allowing your pen to flow freely across the page. Release the need for this drawing to look "right" and embrace the freedom of whatever wants to emerge.

Extra Challenge: *Try using your nondominant hand and blind contour at the same time.*

EXERCISE 3:
Shadow Drawings

Drawing shadows is a simple and easy way to capture unique shapes and images with a little help from the sun.

Head outside and start to see where the light and shadows meet. Notice what shadow shapes feel interesting to you and place your sketchbook or your paintings in the path of these shadows so they fall directly onto your page. Trace these shapes or parts of them and see what interesting designs you might capture.

Feel free to overlap your shadows.

Extra Challenge: *Seek out shadows that are in motion.*

DRAWING TIPS

- As you move about, notice what kinds of objects, shapes, and patterns you feel intuitively drawn to and play with the various drawing exercises to record what you see.

- Remember to look at both the macro and micro worlds around you. For example, make different drawings of the whole forest, a single tree, one branch, and the details inside one leaf.

- Remember to look up and down instead of only drawing what's at eye level.

- Expand your repertoire by drawing a variety of different things. For example, if you tend to mostly draw botanicals, play with drawing figures, architectural elements, abstract shapes, and objects in your home.

- Play with speeding up and slowing down how fast you're moving on the paper.

- Experiment using many different types of drawing tools such as markers, pens, pencils, pastels, charcoal, paint brushes, and even found objects.

THREE SCAVENGER HUNTS:
Drawing, Photo, and Object

If you ever start to feel overwhelmed or uninspired by all the information in the world around you, we've put together three scavenger hunts to get your inspiration-gathering wheels turning.

Drawing Scavenger Hunt

Using the prompts below, grab your sketchbook (or a stack of your new or in-progress paintings), along with your favorite drawing tools and head out on a drawing scavenger hunt. Feel free to incorporate your nondominant hand or blind contour explorations as well.

- A repeating pattern you find in nature
- An architecture element from your house or a building
- Something you see when you look up
- Something you see when you look down
- The pattern of a textile you love
- Your favorite flower (You can reference this online if you can't find the real thing.)
- A human figure sitting, standing, and in motion
- A human face
- Your beautiful face
- An animal
- An entire tree, a branch from that tree, or one single leaf
- The inside of a cupboard
- Some of your favorite art supplies
- A photo you've taken
- Something meaningful in your home

Photo Scavenger Hunt

Using the prompts below, grab your camera and head out on a photo scavenger hunt. Reference your favorite photos later on when you're working on your paintings.

- Something yellow (or any color you choose)
- Laughter
- Something in motion
- Empty space
- A pop of red
- Something written
- A silhouette
- Something in decay
- A tangle of lines
- Water

- Sparkles
- Something crooked
- Contrast
- The sun
- A selfie

Object Scavenger Hunt

Using the prompts below, head out on an object scavenger hunt to collect the following objects. Keep these items and reference them when you're working on your paintings.

- A leaf
- A love letter (You can write one if you can't find one.)

- A beautiful piece of garbage
- A photo of someone you love
- A favorite poem
- An image from a magazine that makes you feel peace
- The color blue
- Something torn
- Something that brings back a wonderful memory
- A ticket stub or receipt
- A piece of fabric that you love
- The word "inspiration"
- Something you find on the ground
- A favorite book

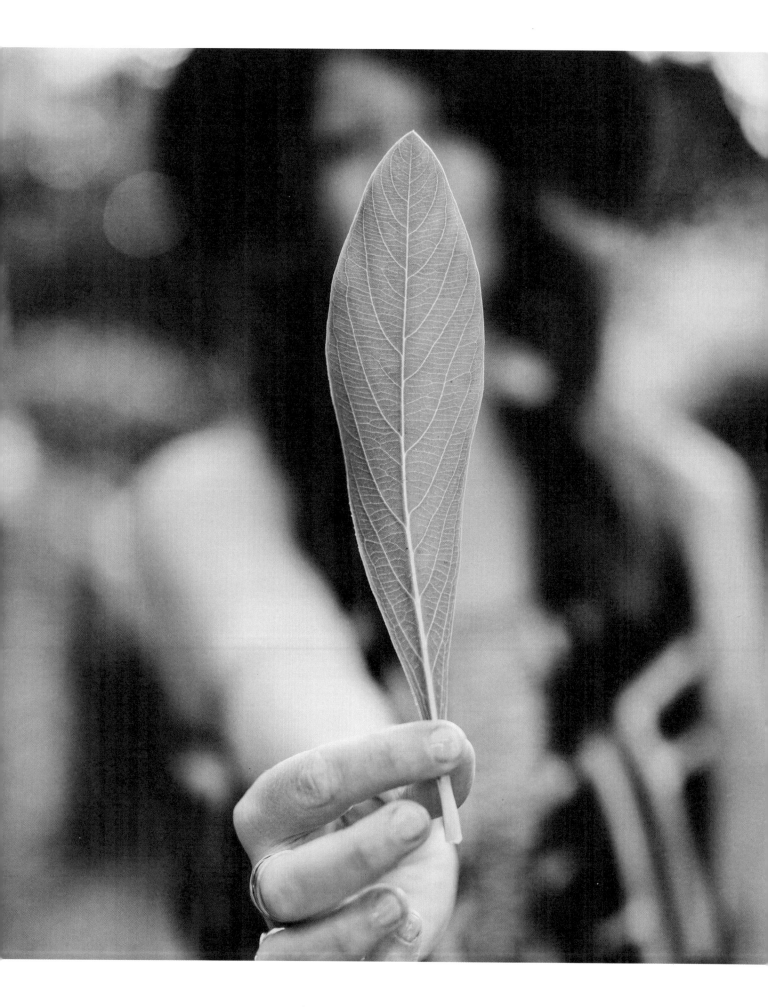

SENSING THE WORLD AROUND YOU

The practice of tuning into our senses provides an immediate and powerful way to drop into the present moment where creativity and possibility are alive and well. Below, you'll find a series of prompts intended to connect you to your senses more deeply and connect you to the world around you in more meaningful ways. We find the results of these practices to be so life-giving.

- **Sight:** Instead of seeing the world as a one big blur, challenge yourself to look for the color red (or choose another color). Notice where you see triangles (or choose another shape). Find the places where shadow and light mingle and dance and seek out interesting patterns and textures. What catches your eye when you walk down the street or through the forest?

- **Sound:** There is so much sound in the world, often we hear nothing at all. Find a place to simply sit and listen deeply for three full minutes . . . or longer. Tune into the full soundscape of the world around you, including the louder, more obvious sounds, as well as the quieter, more subtle sounds. Allow your imagination to play with what you're hearing.

- **Touch:** Try moving through an entire day with your sense of touch leading the way. Start when you wake up by noticing how your sheets feel on your skin. How does your cup of coffee or tea feel in your hands? What other interesting textures can you explore throughout your day? Finger painting is a great way to get more *in touch* with your art!

- **Smell:** Bring the intention of deep breaths and aromatherapy into your day. Slow down and smell your food before you eat it. Notice how the air smells when you step outside. Light some candles or incense as a way to consciously invite ritual through scent. And, of course, stop and smell the flowers.

- **Taste:** Developing a more sophisticated palate simply means paying more attention to how things taste. Try slowing way down when you eat to see if you can distinguish distinct flavors in your mouth. Step into new territory by trying a food or drink you've never had before. How do spicy, salty, and sweet make the rest of your body feel?

As you practice tuning more deeply into your senses, consider how the information you receive from your sight, sound, touch, smell, and taste might make its way into your visual language and artistic expression. How could your most inspired senses become a jumping-off point for your next group of studies? This is a great time to think outside the box and get creative!

WRITING INQUIRY:
Your Inspiring Life

Now that you've started to tune into the world around you as a source of inspiration, take a few minutes to dive even deeper into your personal archives of preferences, desires, and life-long loves by responding to these writing prompts.

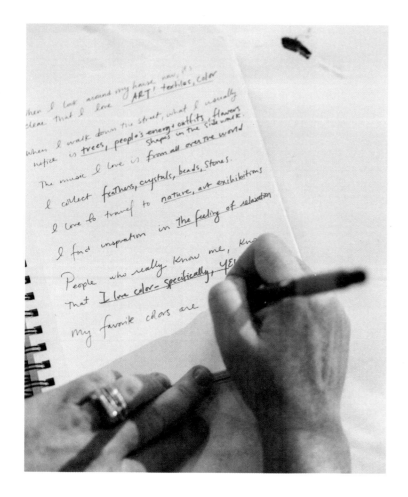

When I look around my house now, it's clear that _____.

When I walk down the street, what I usually notice is _____.

The music I love is _____.

I collect _____.

I love to travel to _____. (Or, I *want* to travel to _____.)

I find inspiration in _____.

People who really know me, know that _____.

My favorite colors are _____.

My art style could be described as _____. (Or, I *wish* my art style was more _____.)

INTEGRATE AND CREATE

In this chapter, we gathered inspiration from the world around us through drawing practices, scavenger hunts, opening up our senses, writing about our life, and improvising with some of our favorite shapes.

Now, it's your time to integrate and create.

Remember, there's no right or wrong way to move forward. As always, you can start new paintings or add layers to works-in-progress. We suggest starting with whatever painting is calling to you and

seeing where that leads you. You only need to have the next idea, so don't get ahead of yourself. One small move leads to the next, and it's impossible to know where it's all going.

Stay present and enjoy the ride.

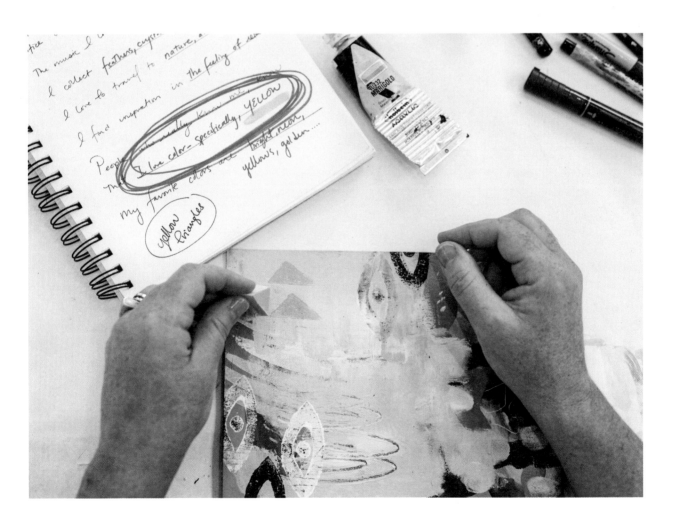

Jumping-Off Points

If you're feeling unsure about how to begin, here are a few prompts to get you going:

- Take one of your favorite drawings or an element from one of your drawings and repeat it in a few different ways onto your paintings.

- Explore a nondominant hand drawing, blind contour drawing, and shadow drawing directly onto your paintings.

- Circle a few things that stand out from the Writing Inquiry and incorporate them into your paintings.

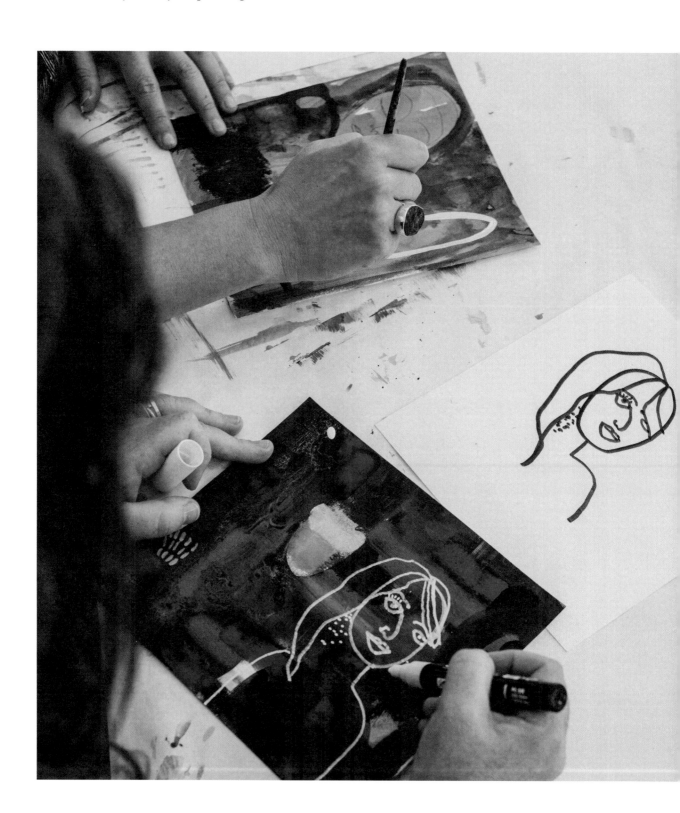

- Create a painting using each of your senses as inspiration.

- Close your eyes and draw to one of your favorite songs.

STUDENT GALLERY

Gathering Inspiration from Your External Landscape

This is a sampling of paintings completed by *Fresh Paint E-Course* participants.

TOP ROW, FROM LEFT:
- *Laura*
- *Kama Solevad*
- *Julia Budden*

BOTTOM ROW, FROM LEFT:
- *Sharon Ruttonsha*
- *Elizabeth Teal*
- *Robin L. Davisson*

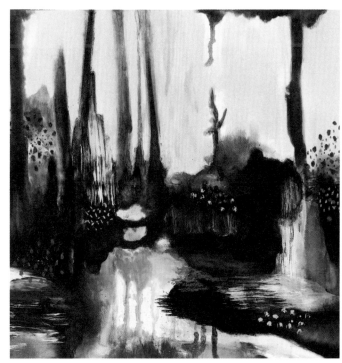

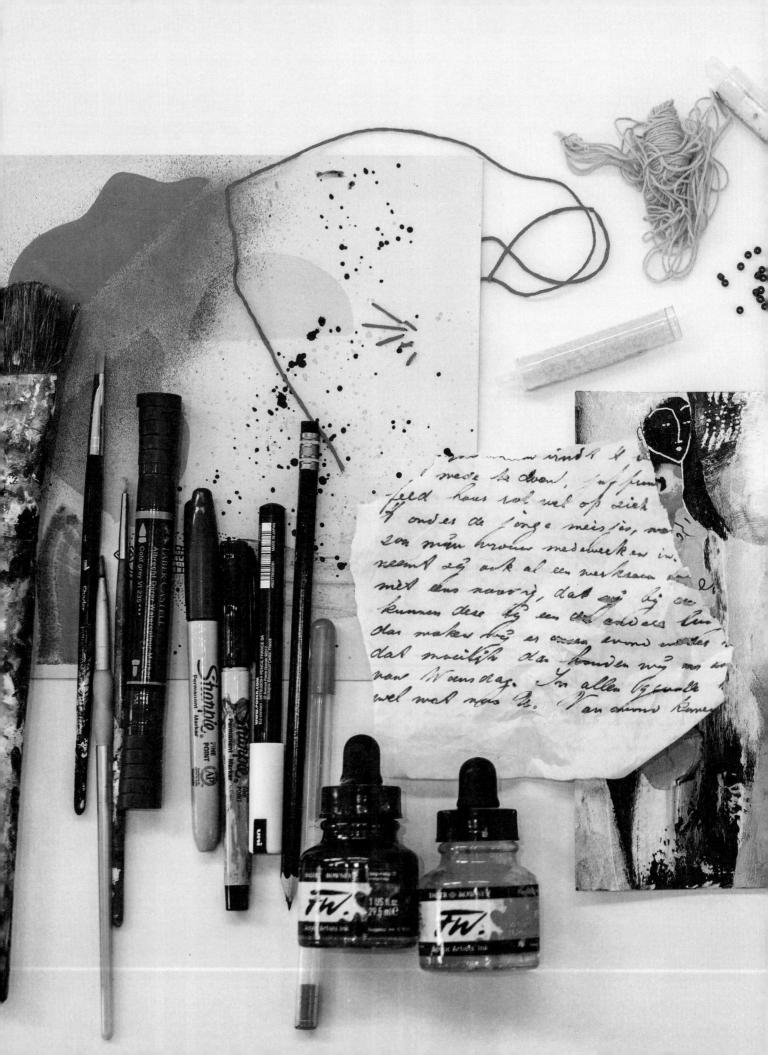

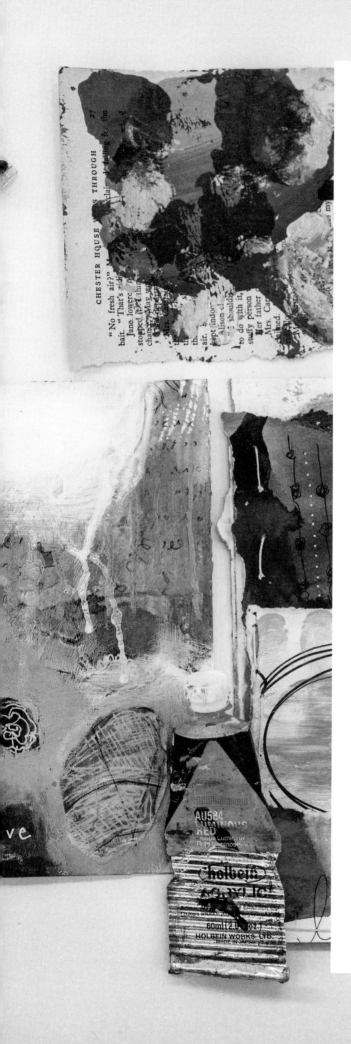

5

EXPANSION WITH NEW MATERIALS

YOU MAY RECALL FROM the beginning of the book that the eighth "ingredient" for finding your own style is Expansion: *Continually growing your knowledge of new materials.*

With that in mind, we're excited to introduce you to an array of some of our favorite art materials we affectionately call the *Art Salad Bar*—an inspiring buffet to satisfy your creative cravings!

As always, this chapter is not about following step-by-step instructions to yield a specific result. On the contrary, it's about opening up to new ways of thinking about your materials and what's possible when you approach them with playfulness, courage, independence, and curiosity.

Our hope is that these ideas will serve as seeds of inspiration that will continue to bloom and grow in ways you can't even imagine. Remember, there is no "right" way to work with these materials and techniques. In fact, the more you think of them as jumping-off points, the easier it will be to make them your own.

WRITING INQUIRY:
Your New Materials

Before we dive into new materials, take some time to reflect on your past, current, and future relationships to different creative materials and processes through this Writing Inquiry:

I have always loved creating with _____.

Lately, I have been curious to explore creating with _____.

One art medium I have been afraid of is _____ because I think _____.

An art medium I enjoyed working with as a child is _____.

I wonder what would emerge if I were to combine _____ with _____ and perhaps even a little bit of _____.

I once tried working with _____ but never picked it up again because _____.

If I could work with ANY new material in my one hundred paintings, I would be most excited to work with _____.

I find _____ (art material) so frustrating!

I LOVE, LOVE, LOVE _____ (art medium) because when I work with it, _____ happens.

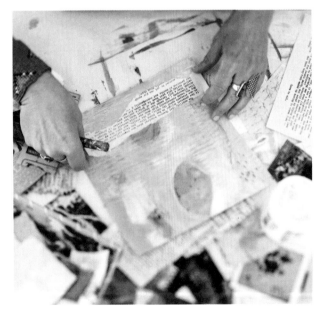

MARK MAKING
WITH BRUSHES

It's easy to pick up a paint brush and use it in the very same ways you've always used it. We tend to be creatures of habit like that. However, that very same familiar tool also has the potential to open up exciting new worlds of mark-making expression when you get curious and start pushing the boundaries of what's possible.

One way we like to experiment with our brushes is by using watered-down black paint on white cardstock or directly on our watercolor paper. This stark black on white contrast makes it easy to focus on the marks we're creating without worrying about things like color choices.

To begin your explorations, gather a variety of brushes and start to play with all the different ways you can hold each brush. Try loosening and tightening your grip, holding it with just two fingers, using your nondominant hand, holding it at the very end or close to the bristles, and trying out a variety of pressures.

Next, experiment with all the different surfaces on your brush. For example, the flat side, tip, corner, and handle of each brush will all produce different shapes and effects. See how many unique marks you can make with just one single brush.

Another way to experiment with your brushes is by playing with the quality of your lines. Here are a few prompts to get you going:

- Move between thick and thin lines by applying more and less pressure as you drag and twirl your brush across your paper.

- Create "skipping" marks by rhythmically lifting up and pressing down.

- Spin your brush as you hold it in one place.

- Hold your brush in your nondominant hand as you make one long meandering line.

- Play with these prompts: curvy, delicate, nervous, jagged, bold, circular, constricted, flowing, and long.

When you're finished exploring your brushes, consider what other materials might be made into mark-making tools. Things like leaves, sticks, pinecones, makeup tools, cookie cutters, toothbrushes, combs, cotton swabs, utensils, chopsticks, old pens, and plastic tops are all great options.

Think outside the box and see what you can find. You just might stumble across your signature mark-making tool!

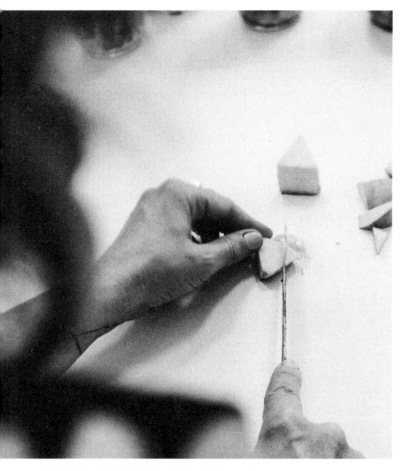
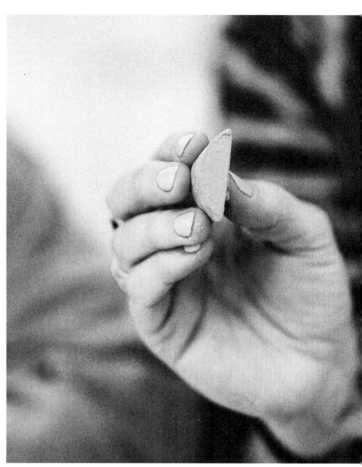
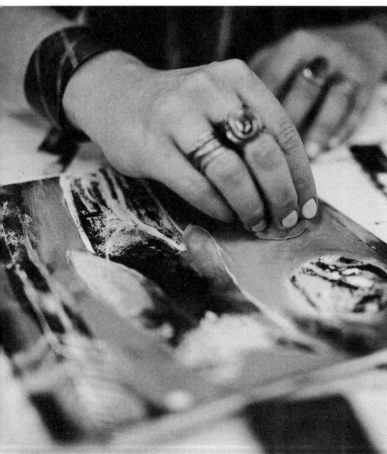
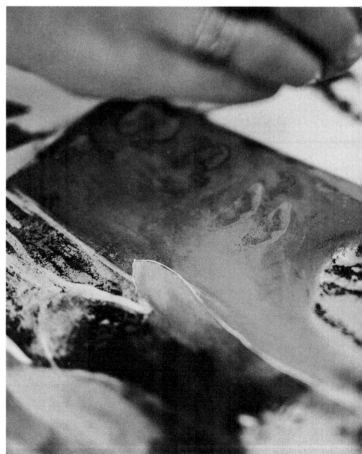

STAMPING WITH VEGGIES

As we mentioned in the last section, we love experimenting with nontraditional materials that make unique and unexpected marks, and one of our favorite places to find these items is right in our kitchen or garden.

Some of our favorite unusual mark makers are vegetables, and we especially love working with potatoes because they're inexpensive, easy to carve, and offer an infinite number of options when it comes to creating shapes for stamping. We also love that potatoes are temporary, and no two potato stamps will ever be *quite* the same.

1 To create your very own potato stamp, find a sharp knife and a proper surface to cut the potatoes on. We like to cut them in half to create two smooth flat surfaces to begin with.

2 Once the surfaces are exposed, wipe them down with a paper towel or rag to remove any surface liquid and then cut the potato into any shape you like.

Remember, you can always keep cutting and changing the pieces to create any number of different shapes and sizes, so enjoy experimenting with this naturally inspiring medium. Also take note of your "off-cuts" and the many sides of your potato. Over the years, we've created some of our favorite shapes completely by accident!

Feel free to use these same guidelines to experiment with other veggies (or fruits). Some of our favorites are the bottom of a celery bunch, a corn cob, the inside of a pepper, the rind of a melon, and a slice of eggplant.

The organic stamp-making possibilities are truly endless!

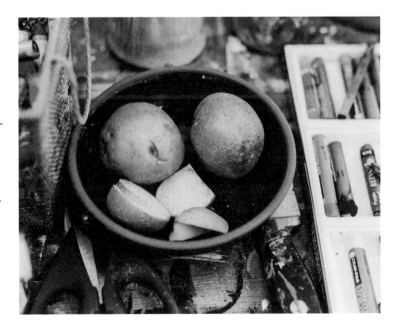

TRANSFERRING IMAGES WITH CARBON OR GRAPHITE PAPER

We learned this easy and satisfying way to add images to paintings from our friend, Orly Avineri, and we're excited to share it with you. This technique is especially helpful if you want to add an image from a photograph or magazine into your painting but you're not feeling confident enough to draw it by hand. We also love the unique effect of transferring images this way.

To begin, find an image you want to use. If the image is precious and you don't want to draw directly onto it, you'll want to make a photocopy. Place your carbon or graphite paper, also called *transfer paper*, with the carbon or graphite side facing down on your painting where you'd like the

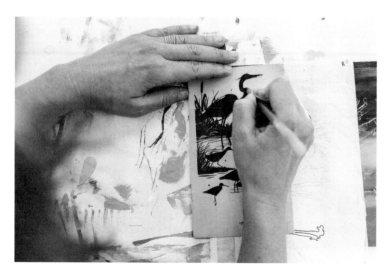

image to go. (Do a little test on a scrap to make sure you have the correct side down.) This paper comes in many different colors. To make your lines pop, we suggest working with dark carbon paper on lighter surfaces and vice versa.

Next, place your chosen image on the top of the carbon or graphite paper. Feel free to tape it all down to keep it in place or just hold it firmly. When the image is in place, trace around the image with a pen, pencil, or stylus. The sharper your tool, the crisper your transferred lines will appear on the painting.

You can add in as much detail as you'd like or keep it simple. Just remember that anytime you make a line or mark on your image, that line or mark will be transferred onto your painting with carbon or graphite. Feel free to do a test run on a different sheet of paper before you work directly on your paintings to get the hang of it and see the results.

You can layer in transferred images anytime into your in-progress paintings or start out with this technique as a first layer.

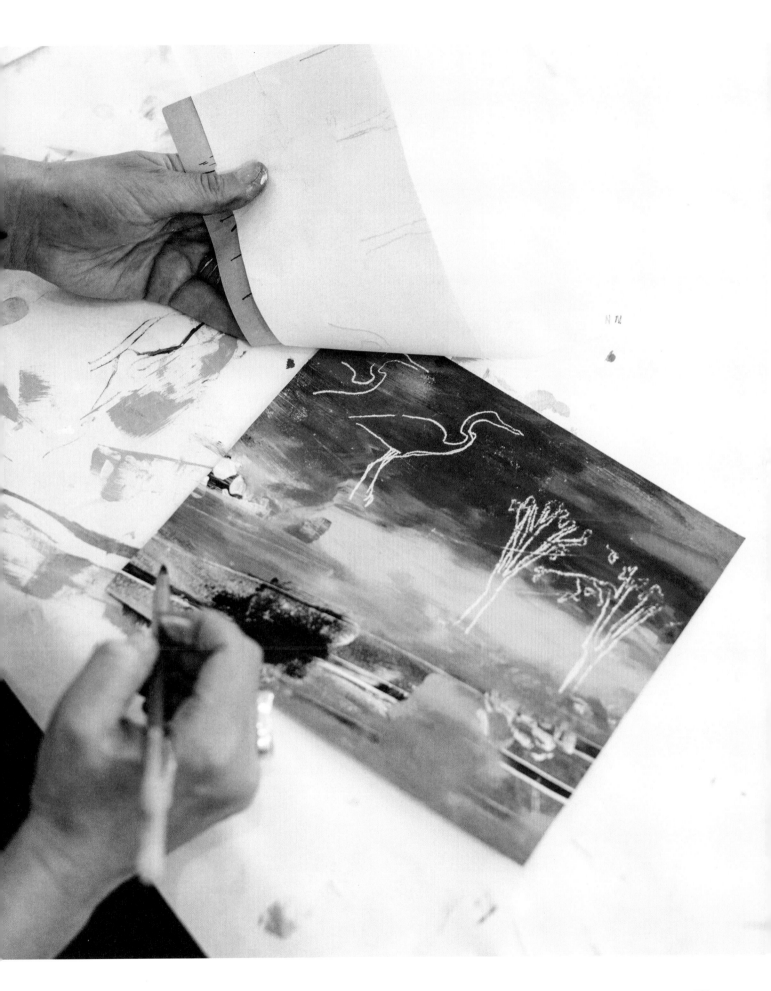

CARVING RUBBER STAMPS

While it's easy to buy premade rubber stamps from the art supply store, we believe creating your own homemade stamps is a much more authentic, satisfying, and exciting way to infuse more of *your* unique style into your creations.

To create your personalized stamp, you'll need a soft rubber carving block and a linoleum carving set, both available at most art supply stores or online.

Each knife in your set will have a different shape, so we suggest doing a bit of trial and error to become familiar with what kind of marks and lines your knives will create. Of course, any time spent experimenting with new tools is time well spent as you expand your creative fluency and ability to express your truest desires.

When you feel comfortable with your carving tools, it's time to start thinking about your stamp design. Remember, your design can be super simple or incredibly intricate—both are satisfying ways to create, and we hope you'll make more than one stamp. Once you get the hang of the material, it's very easy and also very addicting!

To make your carving process easier, you can draw your design onto your rubber carving block with a pen or pencil first, or you're welcome to free-style carve if that feels more interesting to you. Depending on your design, you may want to incorporate a variety of knife tips to get the look you want. You can also cut up your rubber carving block into any shape before you begin.

Once you've carved your stamp, it's time to start experimenting with how to put your stamp into action. Use your fingers or a brush to apply paint to your stamp and feel free to play with both fluid and heavier bodied paint to see what works best. You can also add more than one color to your stamp and experiment with applying different amounts of pressure as you go.

This, friends, is a grand rubber-stamping experiment. Take what works and leave the rest behind.

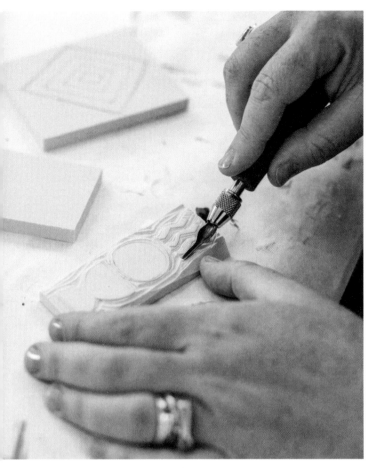

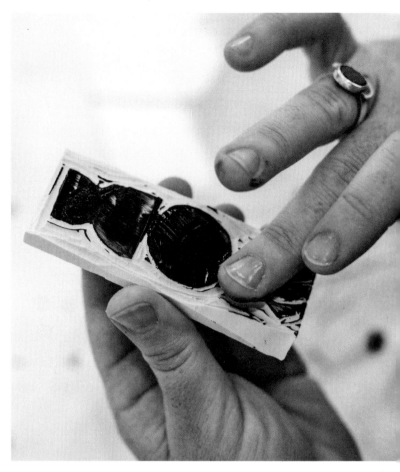

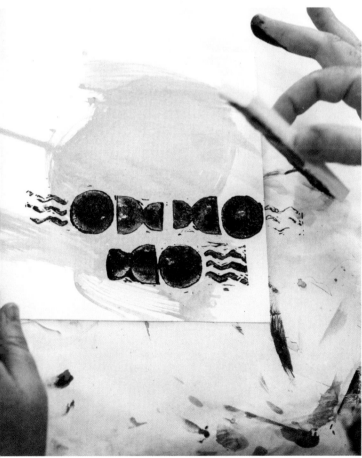

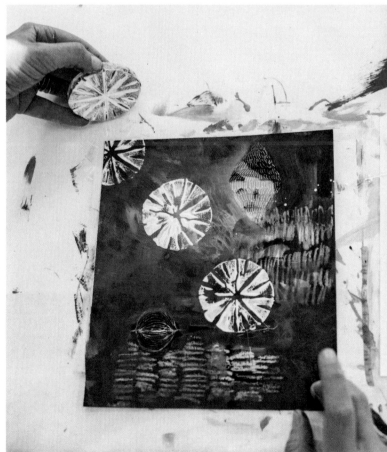

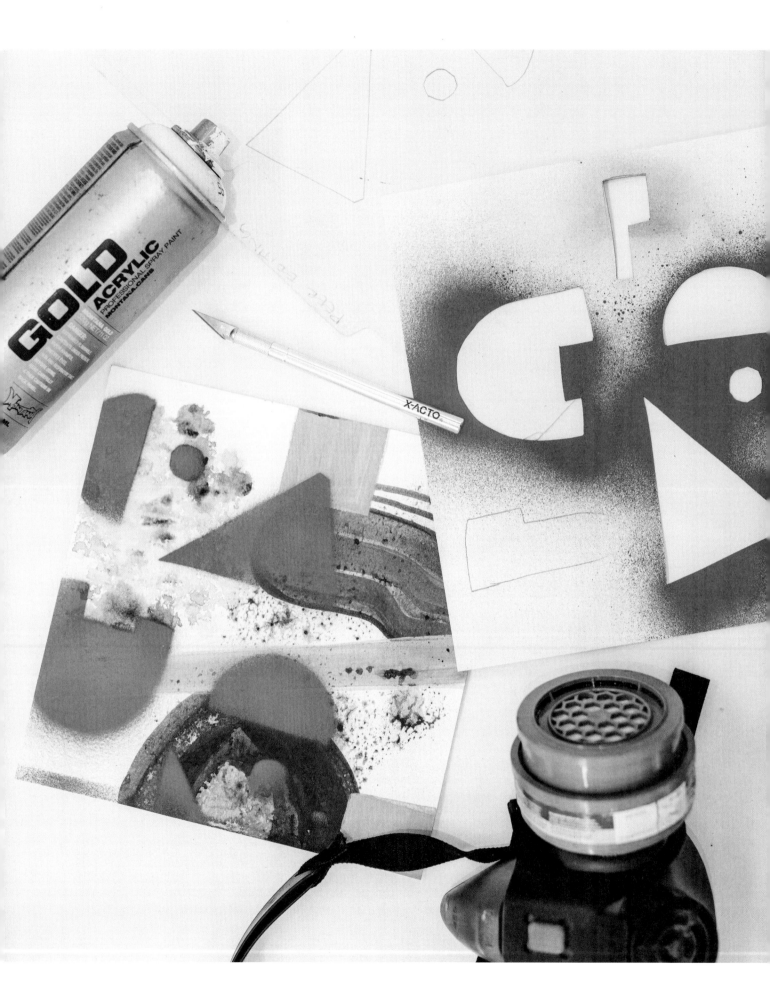

CREATING STENCILS

Stencils are another fun way to add texture and shape to your artwork.

Just like with rubber stamps, there are many prefabricated stencils available for purchase, but making your own is also a wonderful option. Again, we believe this is a great way to bring more of your unique flair into your creations.

There are many ways to make your own stencils, but our favorite low pressure, inexpensive, and easy way to make a stencil is to use a simple manila folder.

Start by drawing your design with pencil or pen onto your manila folder and then use a utility knife to cut away your shapes and designs. You're also welcome to freestyle your cuts if you're feeling brave! Next, pull the off-cuts of your paper stencils away and see what remains. Feel free to make adjustments as you wish.

Next, choose a surface you would like to add your stencil design to. This might be a first layer of a painting, an in-progress painting, or any surface you feel comfortable working on.

Start by positioning the stencil on your paintings. The design can be fully contained on the page or moving off the edge. You can also choose to repeat the stencil image or only apply paint to part of the design, creating another version of your stencil. The possibilities are endless, so again, this is a fabulous opportunity to get into your own groove and play! Pause and listen to what you feel curious about, try things out, and let your own style emerge through the process of experimentation.

We love to use spray paint with our stencils, but we understand spray paint can be toxic and messy and it isn't for everyone. If you do experiment with spray paint, please take care of yourself and your space by spraying outside away from plants, animals, and other people. We also suggest using a simple respirator from the hardware store.

And if spray paint isn't your thing, there are many pumpable spray inks available. Applying acrylic paint with a brush is also an option.

The most important thing is to experiment and find what works for *you*.

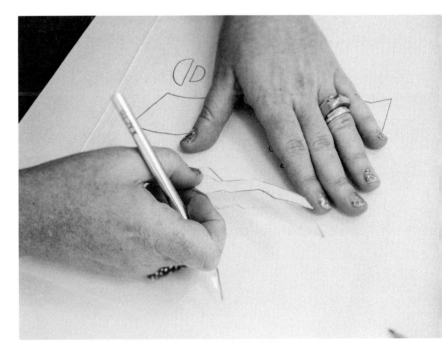

INCORPORATING BEADS, FABRIC, & THREAD

For anyone who's had a passion for fiber arts or beads on your creative journey or anyone who is feeling drawn to these materials now, we wholeheartedly encourage you to explore them in your painting process.

Perhaps you're familiar with quilting, sewing, beading, embroidery, lace-making, weaving, dying, or appliqué. If so, imagine how these skills and passions might be referenced and applied to your one hundred paintings. We'd love to see what you come up with!

The use of beads and fiber are as old as human beings themselves. Often, we adorn ourselves with these beautiful items or give them away as meaningful gifts. Lynx has a lifelong practice of working with tiny beads because her mom was the owner of a bead shop, and this is a perfect example of

"stitching" past experiences with present pursuits. It's that kind of integration of creative passions that creates the space for truly unique expressions of style to occur.

Have you ever quilted? Sewn clothes? Made jewelry? Even if you've just dabbled in any of these mediums, perhaps you have some supplies you could pick up and incorporate into your paintings?

Here are some ideas of how you might consider integrating these mediums into your work. Of course, these are just ideas. You are free to experiment with these mediums in any way you please!

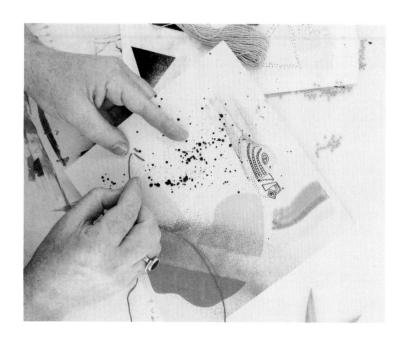

- Embroider with embroidery floss directly onto your painting.

- Hand sew fabric scraps or cut shapes onto your painting.

- Use a sewing machine to create a line design onto your painting.

- Sew beads onto your painting using a needle and thread.

- Glue yarn or other cord into a design on your painting.

- Using a darning needle, use yarn as a mark-making design element in your paintings.

INTEGRATE
AND CREATE

Now that you've experienced the Art Salad Bar, we hope your creative cup is overflowing and you're inspired to play with your new materials. It's time to invoke your curiosity and put on your brave boots as you set out to explore some new ways to create.

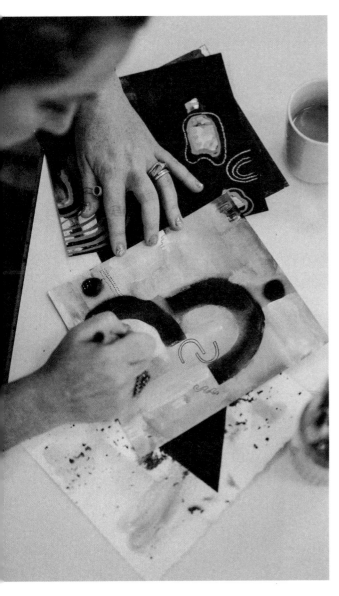

Begin with the mediums we've offered here and also feel free to add in your own favorite art-making materials whenever you feel inspired. Follow your curiosities as you ask yourself, *"I wonder what would happen if I mixed* _____ *with* _____*?"* Those are the whispers of your authentic creative voice coming through!

Remember that you can do no wrong.

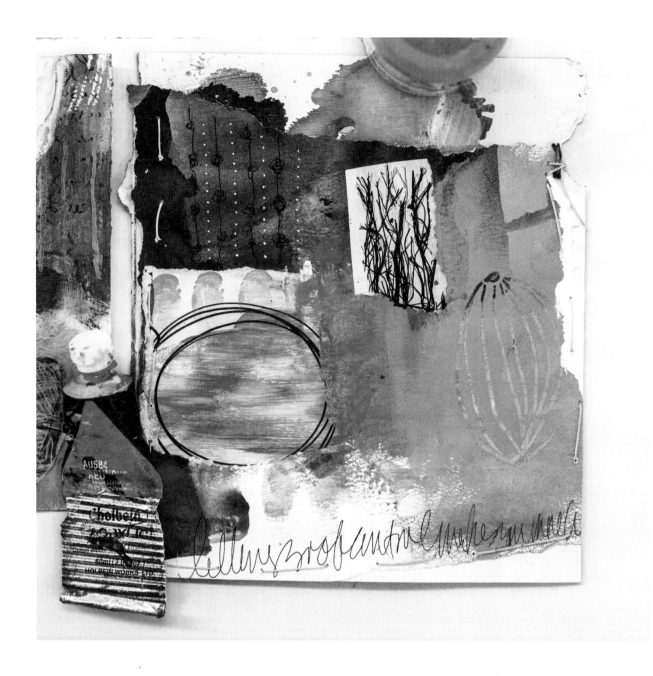

Jumping-Off Points

If you're feeling unsure about how to begin, here are a few prompts to get you going:

- Build up layers of shapes using potatoes and other veggie stamps and alternate colors in each layer. We suggest allowing each layer to dry before adding the next layer.

- Look for new mark-making materials to play with. Nothing is off limits! Experiment with contrast by stamping light colors on dark colors or cool colors on warm colors.

- Stitch one of your favorite shapes onto your painting with thread or stitch a piece of fabric onto your painting.

- Transfer an image onto one of your in-progress paintings using carbon or graphite paper.

- Hand carve a rubber stamp with a symbol that has meaning to you and find different ways to use it in your paintings.

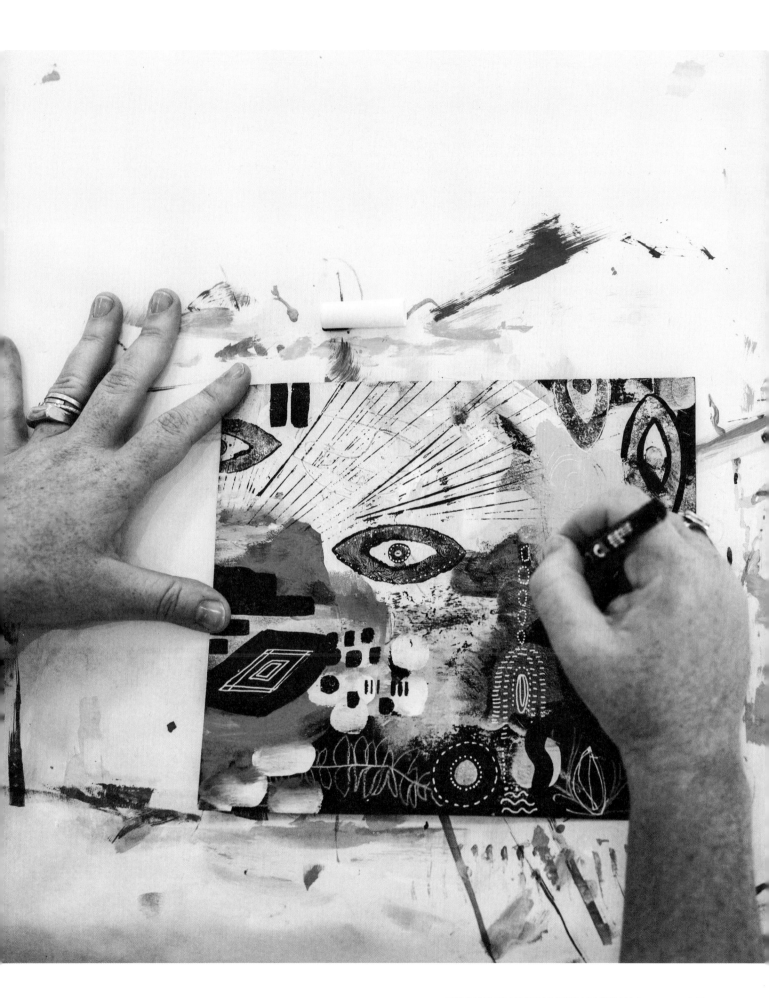

STUDENT GALLERY

Expansion with New Material

This is a sampling of paintings completed by *Fresh Paint E-Course* participants.

TOP ROW, FROM LEFT:

- *Ginny Liskow*
- *Maureen Kelly*
- *Elsa Katana*

BOTTOM ROW, FROM LEFT:

- *Cordelia Peacock*
- *Belinda Sigstad*
- *Dalene Woodward*

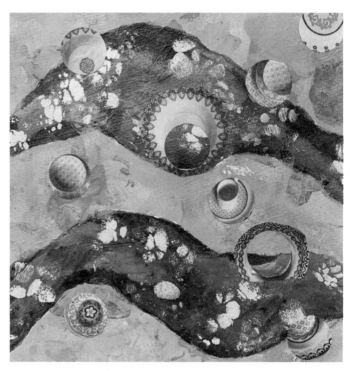

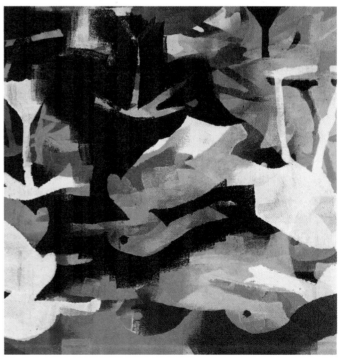

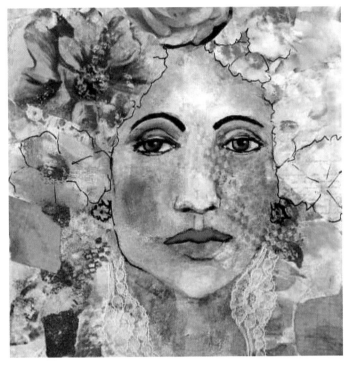

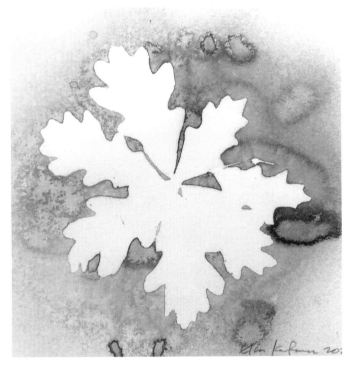

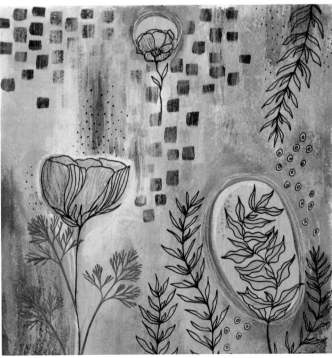

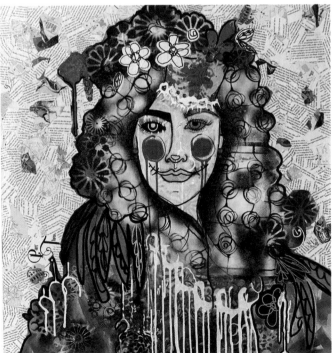

6

FOR THE LOVE
OF COLOR

WE'RE *VERY* EXCITED TO SHARE this chapter with you because it's all about one of our greatest loves—color!

For years, we've jokingly called ourselves *chromasapiens* because we find color to be one of the most endlessly fascinating parts of life and art. We love how color brings art to *life*, and we also love the many ways we can infuse our lives *with* color.

From the way we dress, decorate, accessorize, cook, create, beautify, garden, and move through the world, we're constantly making choices about color whether it's conscious or not. Those choices, in turn, have the power to uplift, soothe, stir, unite, and either set us apart from or blend us into a crowd.

CREATING A RELATIONSHIP WITH COLOR

While color is a part of almost every aspect of our life experience, it's also something that can easily go unnoticed. In this chapter, we'll take the time to notice, collect, experiment with, and get to know colors through a variety of exercises and prompts. Through this process of befriending color, we'll naturally discover a great deal about our personal color preferences, which will support the development of our painting style.

The reason we're dedicating an entire chapter just to color is because we believe color is one of the most vital aspects of any painting process, and it's also a telltale sign of creative style. The way we

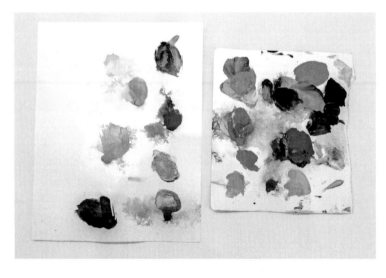

mix, mute, pop, and combine color has the power to create an entire mood, and how we do this is an adventure all on its own.

Remember, there is no right or wrong way to work with color, and that's really the point when it comes to developing a signature style. This chapter is all about creating a very personal and intuitive relationship with color that is meaningful to you, not one that is prescribed by a book about color theory or dictated by the Pantone Color of the Year. Let's leave all those "shoulds" behind, shall we?

If you've ever felt overwhelmed or confused by the wide, wonderful world of color, we understand. It can be incredibly technical, or it can simply be *felt and responded to*. In this chapter, we're asking you to feel and to trust.

Your way with color is the right way.

WRITING INQUIRY:
Your World of Colors

To begin, let's explore some of the ways you currently relate to colors with this freeform Writing Inquiry.

Blue makes me feel _____.

When I look around my house, I see a lot of these colors: _____.

Yellow makes me feel _____.

One of my favorite places, _____, is full of these colors: _____.

Red makes me feel _____.

When I look in my closet, I see a lot of these colors: _____.

Green makes me feel _____.

I generally avoid this color: _____.

Orange makes me feel _____.

When I was a kid, my favorite color was _____.

Purple makes me feel _____.

Currently, my favorite color combination is _____.

White makes me feel _____.

When I close my eyes right now, I see _____.

Black makes me feel _____.

If I had to choose a color for my name, it would be _____.

Metallic colors make me feel _____.

People probably associate me with this color: _____.

COLOR PAIRING

Color pairing is all about exploring the relationships between various colors—one of our favorite pastimes!

Befriending Colors

We like to think of colors as "friends"—friends who we have the pleasure of getting to know more and more over time.

In fact, we believe spending time and experimenting with a color is really the *only* way to develop a personal and deep understanding of its intricacies. The more you work with a color, the more you learn about how it behaves next to other colors, what happens when you mix it with other colors, and so on.

Over time, certain colors will begin to feel like old comfortable friends you know so well, while other colors will still feel new and maybe even a little intimidating at first. That's perfect. What's important is to keep deepening your understanding of familiar colors while continuing to forge fresh relationships with new ones.

To ensure you're continually expanding your *color family*, consider buying one new paint color or brand every time you go to the art supply store

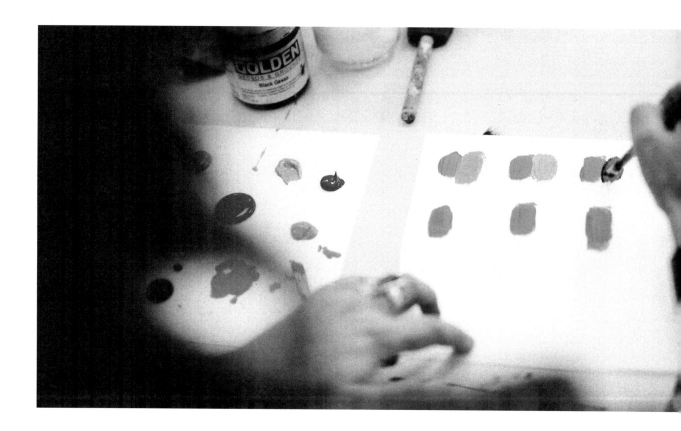

while also mixing the colors you already have.

Pushing your color boundaries in new directions is a great way to keep your work feeling f resh and your style evolving.

It's All About the Combos

A common question we hear is, *"What's your favorite color?"*

This question is always a bit tricky to answer because the way we think about color is less about a singular favorite and more about the dialogue different colors have with one another.

For example, a teal paired with an orange is going to invite a dramatic spark of contrast because these two colors are complementary, meaning they are found opposite from one another on the color wheel. However, a teal paired with an earthy brown will have a much more subdued effect.

In this exercise, we invite you to dive deep into your understanding of individual colors and the infinite possibilities each color holds in relationship to other hues. By exploring one color at a time, you'll not only gain more information about your personal preferences, but you'll also deepen your understanding of the way in which that color relates to the rest of the rainbow—all vital guideposts on your journey towards finding your own unique style.

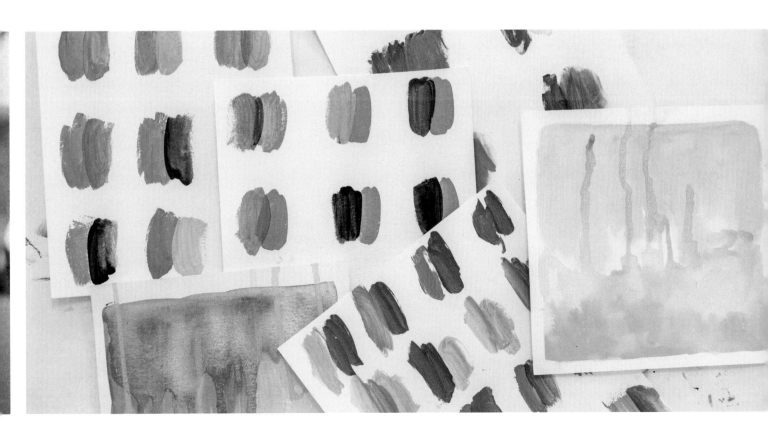

How to Color Pair

Color pairing is simple, fun, and intuitive. You can play with them on your watercolor paper and allow your pairings to serve as a departure point for new or in-progress paintings or, if you'd like to refer to your color pairings in the future, you can keep them separate and create an archive of pairings to reference later. You can also cut them up and make a *pairing deck*.

To begin, choose one color to explore. We'll call this your "starting color." Your starting color can be a color you know and love already, a color you are less familiar with, one you tend to avoid (we highly recommend trying this), or one you mix up on the spot. *"We hope you'll love this exercise so much that you'll be inspired to try it out with many different* "starting colors."

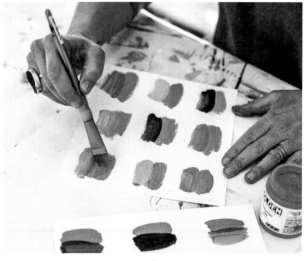

Once you've selected your starting color, add five to ten swatches of it onto your paper. You can lay the color down any way you want. For example, your color swatches might be circles, fingerprints, or quick foam brush marks. They might be wild and free or tidy and organized. How the paint is applied is not important here; what's important is what happens next.

Once you have your starting color swatches on the paper, begin to ask yourself *"What color am I craving next to this color?"* Try not to overthink this, but rather embrace it and let it be personal. When you have a color craving, add a swatch of that color next to your starting color so you can see the two colors next to each other.

After you've added a swatch of color, move onto the next swatch and ask yourself the same question: *"What color am I craving next to this swatch?"*

Another guiding question you can play with is, *"How can I create contrast here?"* Contrast might look like adding the complement of red next to green, light next to dark, muted next to vibrant, and so on. Continue to add different colors and notice how each pairing creates a different effect.

As you move across your paper, adding swatches as you go, allow your old friends to mingle with new friends and pay keen attention to what feels exciting along the way. When you've completed a pairing, you can begin again with a new starting color on a fresh sheet.

If you'd like to create a *pairing deck*, simply cut up each pairing to create a stack to refer to later on. Also be sure to check out the "Integrate and Create" section for more ideas about how to play with color pairing moving forward.

Remember, you might not end up liking every pairing, but exploring with a sense of curiosity is exactly how you learn more about your preferences, while discovering new things along the way. Some combinations might not turn out the way you'd hoped, but you may feel pleasantly surprised by others you hadn't previously considered.

This kind of experimentation, in turn, leads to greater clarity and confidence—two important ingredients in finding your own style.

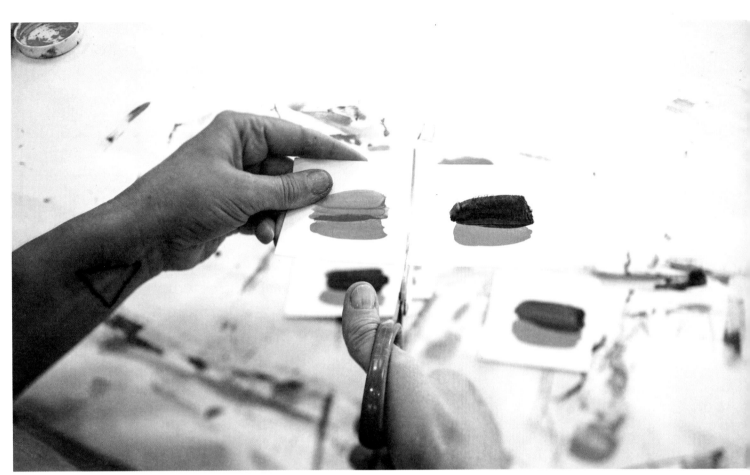

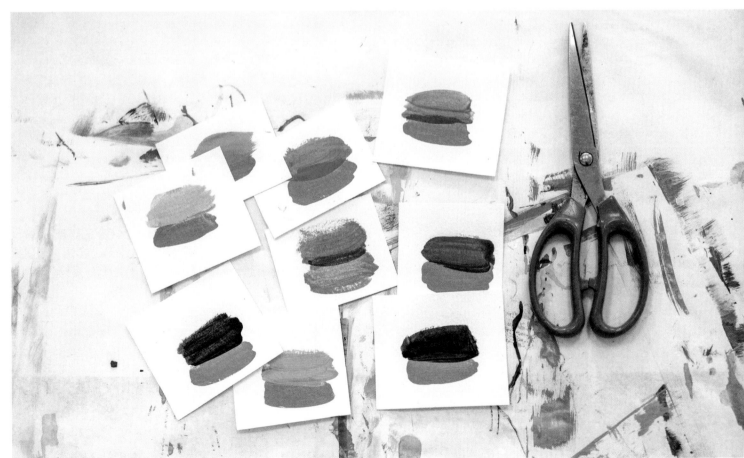

MINI ABSTRACT PAINTINGS

We hope the "Color Pairing" exercise helped you to connect to your intuitive sensibilities and personal cravings around color while providing new color combination inspiration for you to play with in your paintings.

In the "Mini Abstract Paintings" exercise, we'll keep exploring the idea of connecting to intuitive cravings, but this time, we'll do it with more than two colors at a time. If you'd like to reference these color studies later, feel free to work on clean sheets of paper and set them aside when you're done. You can also work directly onto your stack of watercolor papers to create first layers or continue working on paintings in progress. Who knows, you might even create a mini abstract painting you love with just one single layer of color craving.

The practice is simple and freeing. To begin, choose one color you feel drawn to and add a little bit of that color to your page in a way that feels expressive and painterly. Next, take a look at that color and ask yourself, *"What color am I craving next?"* or *"How can I create contrast here?"* Follow your intuition and curiosity as you add the color you're craving next to the first color. Continue this practice of adding more colors until you feel content with the number of colors in your color family.

If your mini abstract painting is feeling a bit chaotic, add more of *one* of the colors to create more unity and cohesion. Notice how emphasizing one color changes everything.

We love this exercise because it takes the emphasis off things like mark making, shape finding, and composition and allows us to simply focus on one thing: color. We find this kind of focus or restraint often leads to more freedom and unexpected breakthroughs, and often the results are quite interesting and different than what we're used to creating when we're trying so hard to "make a painting."

We hope you enjoy this little exploration and continue to return to it again and again any time you need a little color inspiration.

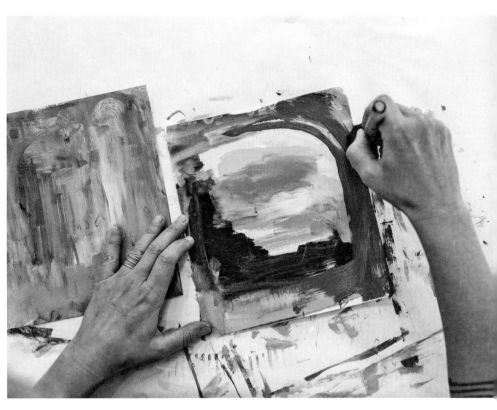

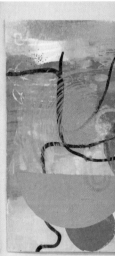

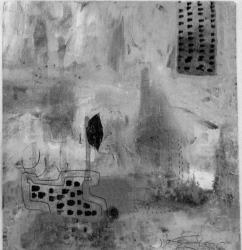

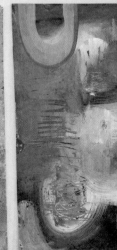

COLOR MIXING AND RECIPE NAMING

Mixing up your own colors with a playful and curious spirit is a powerful way to create a unique feel in your artwork, and that's what this exercise is all about. We hope you'll let go of needing to follow someone else's rules or recipes and simply let yourself get lost in the process of experimentation. This is all about improvisation and staying on your color-mixing toes.

To begin, put any version of blue, yellow, and red you feel drawn to on your palette or paper. With a fresh brush, mix any two of these colors and notice what begins to emerge as you swirl the colors together—it's like magic, and you're the magician!

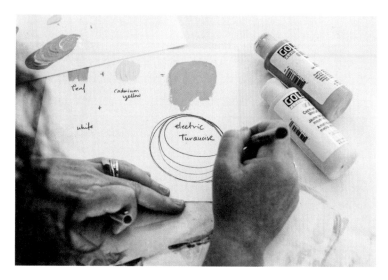

You'll likely find that it doesn't take very much of the darker value to radically change the lighter value, so be aware of that. For instance, if you're mixing blue and yellow to make green, begin by adding just a small amount of the blue to the yellow. You can always add more of the darker value, but it's tough to go the other way if it starts to overpower the lighter value.

We also suggest experimenting with adding white, black, and any other colors you want to explore in your color-mixing adventures. Think mad scientist and go for it.

If you find it helpful, you can write out the recipes and choose your own names for the unique colors you create. For example, you might write: 2 parts medium yellow + 1 part teal + 1 part titanium white = Soft Moss. You can write this recipe right next to the color you created.

If you've ever wanted to be the person who names the colors at the paint store, this is your chance! Have fun with it.

COLOR SEEKING AND FINDING

Color is truly everywhere when you really start to notice it, and that's what this exercise is all about. By recognizing color and paying attention to what draws you to different hues and combinations, you tune yourself into the world of color. This kind of mindfulness fills your basket of inspiration, and helps you develop a sophisticated and personal color sensibility.

Some of these prompts will invite you to gather color in different ways and others will simply ask you to notice it. Either way, we hope these exercises inspire you to start experiencing color in new ways.

1 Go on a photo scavenger hunt with your camera. Choose one color to hunt for and take pictures of that specific color when you come across it.

2 Cut out colors and color combinations that you feel drawn to from pictures in old magazines. Play with arranging the different pieces of paper to create color families.

3 Challenge yourself to wear a color you don't normally wear. Try doing this every day for one week.

4 Cook a meal that includes a full rainbow of colors.

5 Collect colors from nature. Rocks, leaves,

flowers, and feathers are all great options. Feel free to create a nature mandala, sculpture, or altar from your collection.

We've also included different ways to incorporate what you gather and notice into your paintings in the "Integrate and Create" section below.

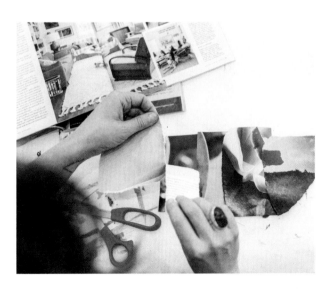

INTEGRATE AND CREATE

Well, this is an exciting moment. With all the color studies you just did, you're likely full of color inspiration and ready to start adding it to your paintings. As always, you can circle back and add new layers to in-progress paintings, or you can begin new fresh paintings . . . or both.

Below, you'll find some ideas to get you going, but this is your time to play and experiment in whatever way you choose.

If you're feeling stuck, you can always ask yourself, *"What color am I craving?"* or *"How can I create contrast?"* Other questions that might be helpful are: *"What's my next baby step?"*, *"How can I create cohesion?"*, or *"What am I willing to let go of?"*

Jumping-Off Points

If you're feeling unsure about how to begin, here are a few prompts to get you going:

- Find a painting in progress that currently feels too chaotic. Ask yourself what color you're craving and cover over eighty percent of the painting with that color. This kind of bold

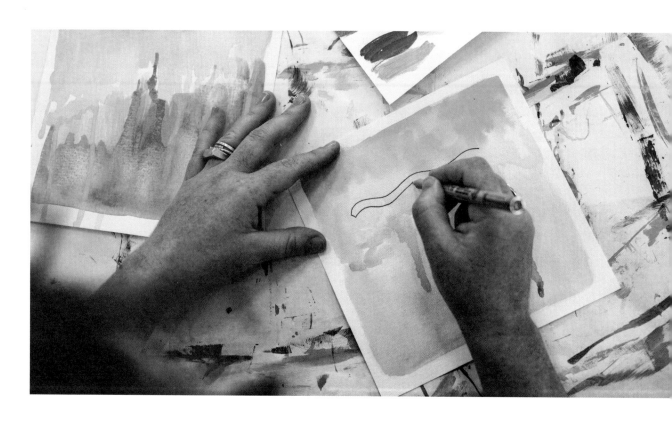

move will help create more overall cohesion and unity in the painting. It will also create quiet space, which you can choose to add more details to after it dries.

- Create a whole painting using your favorite color combo from the "Color Pairing" exercise, plus one more color of your choice to add a bit of pop.

- Using the principles of color craving, create a series of three loose mini abstract paintings using just your fingers, your favorite brushes, and found materials.

- Do a Blind Contour Drawing (see page 50) on top of one of your Mini Abstract Paintings (see page 90) using a paint pen. (Make sure your paintings are dry before adding the penwork.)

- Take a look in your closet and choose three colors of clothing that feel interesting together. Create a painting based on that color palette.

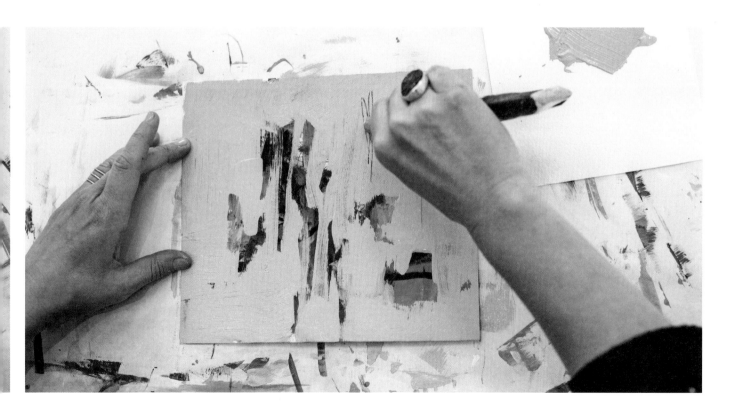

STUDENT GALLERY

For the Love of Color

This is a sampling of paintings completed by *Fresh Paint E-Course* participants.

TOP ROW, FROM LEFT:
- *Alison Hunt*
- *Ute Lambrecht*
- *Gaby Alvarez*

BOTTOM ROW, FROM LEFT:
- *Anita Shortland*
- *Leigh Fairweather*
- *Nadine Shapiro*

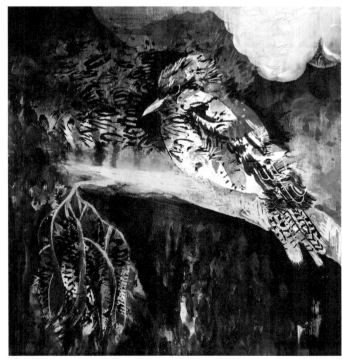

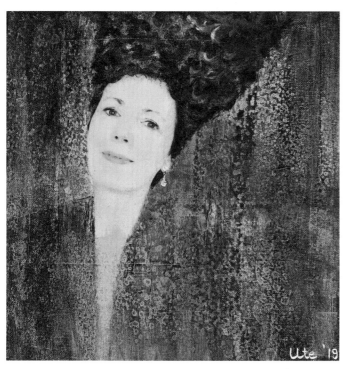

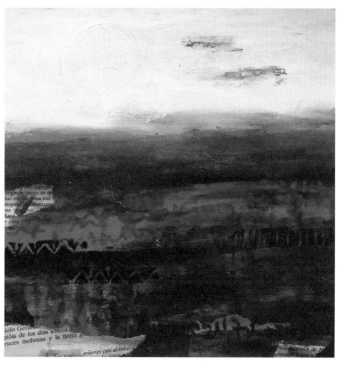

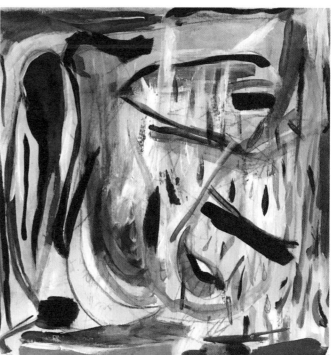

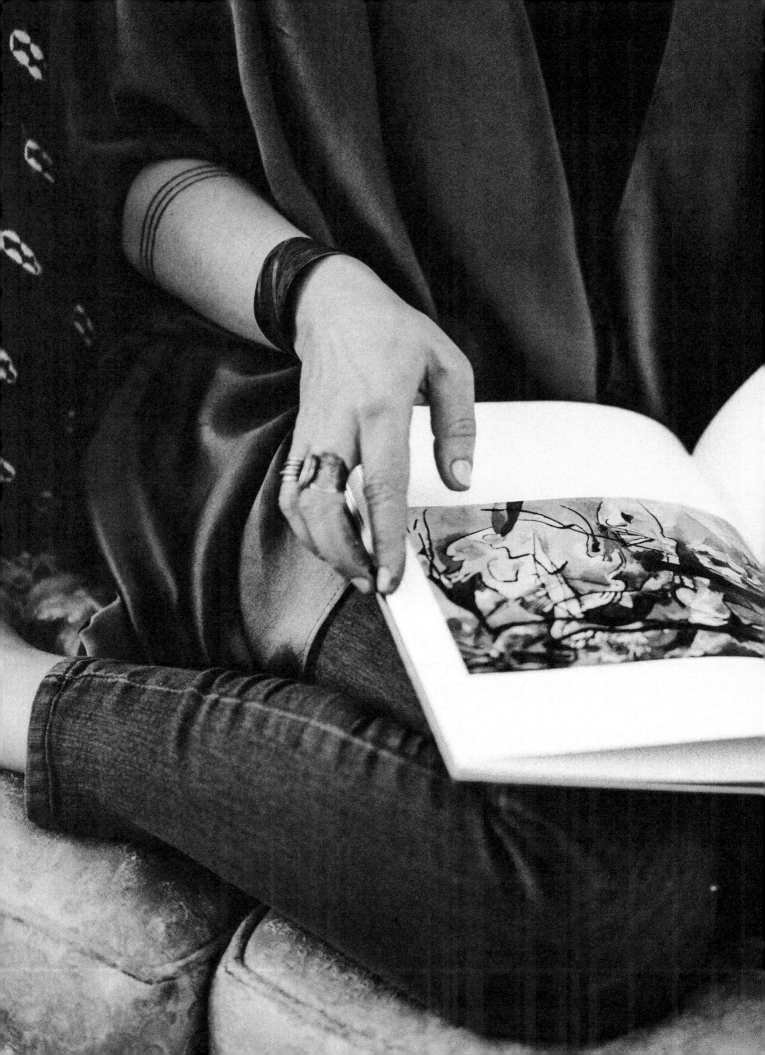

7

INCORPORATING INSPIRATION FROM OTHER ARTISTS

WE BELIEVE THAT GENUINE CURIOSITY, honest self-inquiry, and the ability to metabolize personal life experiences create the foundation for developing a unique creative style. That belief informed our decision to begin this book with an emphasis on inner work, while saving this chapter for last.

That said, it's very natural to be inspired by other artists and art forms—we certainly are! This kind of creative exchange is something we've seen throughout history, and with today's widespread access to the Internet, it's easier than ever to glean inspiration from artists all across the globe.

The way we see it, the problem is not *being* inspired by other artists but *how* we incorporate that inspiration into our own work. This distinction can be a slippery slope, but we're excited to dive into this important conversation with you here.

INTERPRETING INSPIRATION HONORABLY

In this chapter, we'll explore how to be inspired by other artist's work in an honorable way that doesn't disrespect their hard-earned ideas and years of practice. We'll also offer an array of prompts and exercises to put these explorations into practice as we clarify the difference between "being inspired by" and "being overly derivative."

This topic is very near and dear to our creative hearts, and in many ways, it motivated us to write this book. Many of us know how exciting it is to feel inspired by someone else's artwork, and many of us also know how unsettling it can feel to have our work appropriated or copied without our permission. With these two experiences in mind, we hope this chapter offers some loving and clear guidance about how to navigate these sometimes murky waters.

We're excited to dive into this with you!

GETTING SPECIFIC

When you see a piece of art or a body of work you love, it's natural and easy to think, *"Oh I just LOVE that. I'm going to try it myself!"*

This approach of direct copying from outside sources can offer helpful insight when you're new to a medium or a process and have no intention of sharing or selling your work. However, when you're in the business of developing a style that is unique to *you*, it becomes ethically important to be mindful of just how much "borrowing" you're doing from any one particular source.

This is why getting specific about exactly what you feel inspired by is so important.

To dig a little deeper into your personal preferences, ask yourself, *"What am I feeling specifically drawn to or excited about in this piece of art or body of work?"* This one simple question will instantly give you important information about how to incorporate what you like without borrowing *too* much from one place.

Instead of taking it *all*, choose one specific thing you really love and add that to your ever-growing repertoire of inspiration.

For example, you might think: *"I love how the bright teal pops against the brown background to create a visual pop."*, *"I'm drawn to the juxtaposition of large quiet areas of color with smaller fine details."*, *"I'm intrigued by the way the figures are out of proportion."*, or *"I'm inspired by the mixture of yarn, paper, thread, and paint."*

Once you gain clarity about what you feel drawn to, take the time to work with it.

Make sketches or take notes about what you're seeing and what is standing out to you. Ask yourself what you notice first about the piece, what you love

the most, and how you can imagine incorporating what you love into your own art. Let it sink in and simmer. Then, put the work *away* before you dive into your own creative process. All of these practices will help you metabolize the inspiration in a way that becomes more integrated and truer to you rather than looking at it directly *while* you're creating.

When you do sit down to create your own art, try mixing one specific thing you love about someone else's art with your other sources of inspiration to see what kind of fresh alchemy might emerge. By doing so, you're consciously curating and blending many resources without taking too much from any one person or place.

Just like cooking, the more you expand and get to know your ingredients or sources of inspiration, the more comfortable you will feel improvising and cooking up something that is entirely your own.

WRITING INQUIRY:
What You Love and Why

We've all experienced art that has affected us in one way or another. In this Writing Inquiry, we'll explore the different ways we've related to art in our life thus far.

My earliest memory of experiencing visual art was _____. At the time, I felt _____ about it.

These days, the art I love the most can be described as _____.

One artist that has always been a favorite of mine is _____ because _____. I also love _____ and _____ because _____.

One of my favorite paintings is _____. When I look at it, the first thing I notice is _____. My favorite part is _____. The painting makes me feel _____. The painting makes me think _____. I could incorporate what I love into my own art by _____.

If I could spend a day with an artist, it would definitely be _____, and I would ask them: _____.

In an art museum or gallery, I usually find myself drawn to _____ because _____.

An artist or art movement that I would love to learn more about is _____.

Some other art forms besides painting that I love are _____.

Most people don't even think of _____ as art, but I do.

I would love my own art to look and feel more like _____.

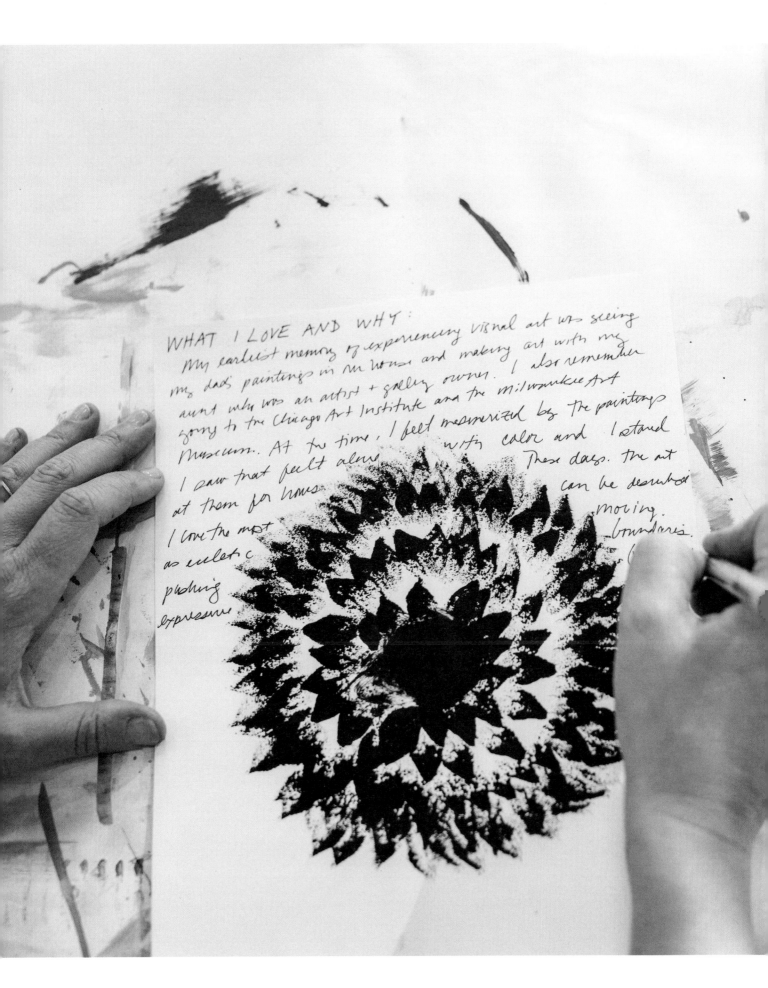

WHAT I LOVE AND WHY:

My earliest memory of experiencing visual art was seeing my dad's paintings in our house and making art with my aunt who was an artist + gallery owner. I also remember going to the Chicago Art Institute and the Milwaukee Art Museum. At the time, I felt mesmerized by the paintings I saw that felt alive ... with color and I stared at them for hours ... These days, the art I love the most ... can be described as eclectic ... moving. pushing ... boundaries. expressive ...

PAINTING CHALLENGE:

Using Art as Inspiration without Copying

Spend some time with one of your favorite paintings mentioned in the Writing Inquiry. Notice *specifically* what you love about it and create a painting or group of paintings inspired by what you love.

Remember, this is about choosing *specific* things about the artwork that really speak to you and allowing that specific information to mix with other sources of inspiration and serve as a guidepost in your own creations. This is *not* about replication or taking too much from one source.

As you create using specific inspiration, continue to weave in your inner explorations, outer explorations, new materials, and the magic of the moment. When you're done, consider drawing upon more than one artist for inspiration and combining those elements to create another set of paintings. What happens when you draw from three or four different artists? The possibilities are truly endless.

Here are some more examples of what might feel inspiring about a painting:

- A type of brush mark
- The energetic quality of a line
- The spaciousness of the composition
- The thickness of the paint
- The size or scale
- Text elements
- The color palette
- A specific shape
- The use of light and dark

SEEKING INSPIRATION IN OTHER ART FORMS

Painters are often inspired by other paintings. Working in the same medium makes that kind of inspiration translation very natural.

However, when we consciously look to other forms of creative expression for inspiration, we not only broaden our pool of ideas, but we also avoid the temptation to appropriate another person's particular painting style or specific work of art.

We've come up with a series of prompts and different ways you might incorporate what you find into your art. These prompts are simply meant as starting points, and we wholeheartedly encourage you to follow your own inspiration incentives. What's important is that you make a conscious effort to seek and find creative inspiration from many different sources. And, as always, have fun with it!

Music
- Listen to music with your eyes closed and allow your pen, pencil, paintbrush, or fingers to move across your paper in response to the music.

- Listen to music and sketch or paint while you listen (with your eyes open this time).

- Create your own music.

Poetry
- Read a poem and notice what kind of colors, images, and feelings it evokes. Try translating those into a visual language and adding them to your painting.

- Add written words from a poem directly into your painting.

- Write your own poetry to accompany or be incorporated into your painting.

Dance
- Dance to one of your favorite songs before you paint and notice how it affects your energy.

- Watch a dance performance with the intention of using it as inspiration in your painting.

- "Dance" lines into your painting as you listen to music.

Sculpture
- Do a blind contour drawing of a sculpture directly into your painting.

- Sculpt some clay before you paint and notice how it inspires your painting process.

- Create a mandala with natural materials and notice if any of the shapes feel inspiring to add to your painting.

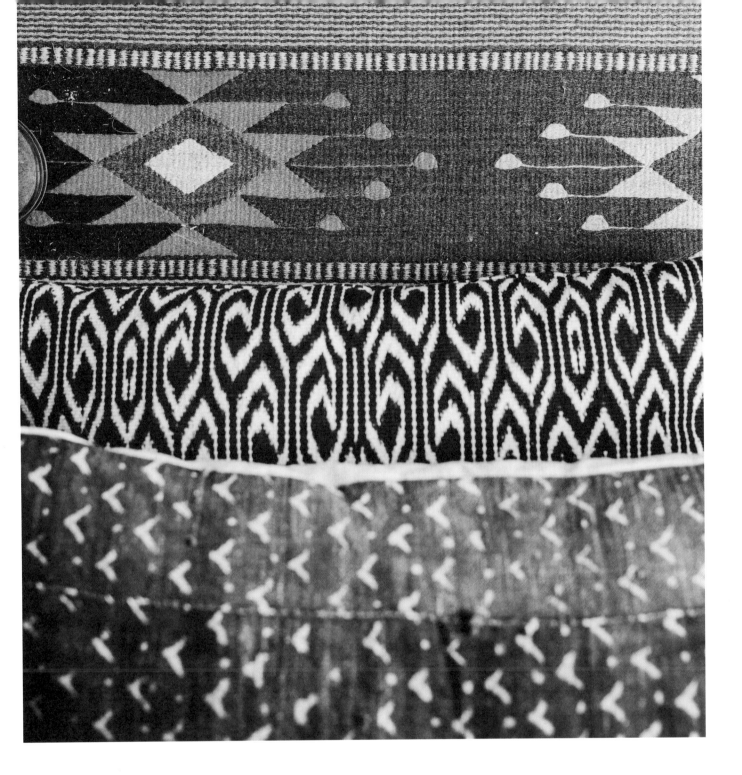

Photography

- Find an inspiring composition in a photograph and allow it to make its way into your painting.

- Go on a photo walk to discover and capture new shapes through your lens.

- Use the colors you find in a photograph as inspiration for your painting palette.

Textiles

- Carve a rubber stamp inspired by a favorite shape you find in a textile.

- Use the colors from a textile as the palette for one of your paintings, and incorporate a scrap or piece of fabric directly into it.

SOME OF OUR PERSONAL INSPIRATIONS

Throughout this chapter, we've asked you what artists and art forms you feel most drawn to and why. We've also asked you to explore the different ways to be inspired by their work without being overly derivative. To finish this chapter, we thought it would be fun to share some of the artists, art styles, and art movements that have inspired us over the years and how we've integrated specific things from them into our own work. We have so much gratitude for all these important teachers and sources!

Flora's Inspirations

Squeak Carnwath's quirky and playful paintings inspired me to have more fun and to let go of the need to create "serious" paintings. They also showed me the power of incorporating the written word into visual art early on in my career.

Cy Twombly's pure, energetic, almost childlike marks gave me permission to stay loose and embrace my own authentic gestures. I often use my nondominant hand to achieve this.

Street Art of all kinds excites me to consider the ways in which art intersects with public spaces to beautify, provoke, and inspire. I also love the raw, bold energy it often holds.

Fauvism is an art movement that took place from 1905 to 1910. The strong colors, bold brushwork, and de-emphasis on things needing to look "real" helped to free me up in the beginning of my painting journey. **Henri Matisse** is one artist I particularly love from this movement.

Melissa Koby is an artist I recently discovered, and I'm so glad I did. Her warm tones, powerful use of negative space, and eloquent commentary on social justice and equality in her illustrations are a soothing and stirring source of inspiration.

Mark Rothko's huge, luminous canvases actually seem to breathe, and they remind me of how stunning quiet space and delicate, transparent layers can be.

Botanical Illustration has been a constant source of inspiration for me throughout the years. I love pouring over books and finding new shapes and patterns to explore in my own work.

I have to include **Music** (of all kinds) in this list because it has played such a central role in my creative process for as long as I can remember. Dancing and painting and allowing my marks, lines, and colors to be influenced by beats and lyrics is something I hold dear.

Lynx's Inspirations

Hilma af Klint's relationship with the spiritual world expressed through color and form helped me to embrace both big shapes and tiny details all in the same work. Her process of "channeling" imagery inspires me to listen deeply within to what wants to "come through me."

Wassily Kandinsky's playful seriousness has allowed me to be silly and fun, while sharing what lies deeply within. His use of color and form, free from representation, granted me access to be expressive, varied, and at times whimsical, while also being honest, authentic, and balanced.

Oliver Vernon's energetic landscapes with sweeping lines and energy coupled with color washes and fine details inspire me to work with contrast both in color and in broad strokes and fine detail.

Jeffrey Gibson's works with painting mostly, but also doll making, beading, sculpture, installation,

and more. I feel inspired by him to combine the mediums that speak to me in a creative, true-to-me kind of way. He also uses words in his work, and I am often inspired to put words into my work, motivated by how he accomplishes this so gracefully.

Martha Graham's approach to dance and movement as a way to express deep wordless truths has been a great source of inspiration over the years. Martha believed art didn't have to be "pretty" to be valuable; she believed the expression of truth and authenticity were queen. Martha often reminded creatives that everyone has something unique to offer into the creative conversation, but in order to access that authenticity, we must practice, practice, practice. Inspired by Martha, I often remember that just showing up and moving color and shapes around with paint and art supplies is a way of practicing my innermost truth. As I continue to show up and practice, I find my

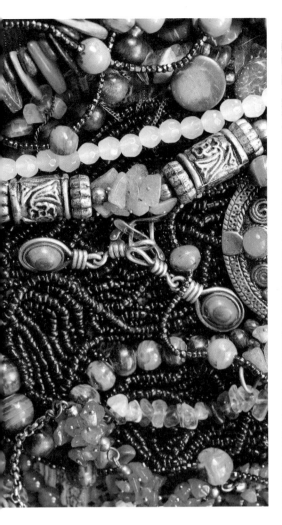

authenticity and expression from moment-to-moment, over and over again.

The World of Jewelry is transcultural and timeless. Human beings have found meaning in adorning bodies through millennia, and the shapes and materials that have been found and formed exist throughout the world. I find that the shapes and designs from continents near and far speak to me about beauty and meaning, and I, too, seek to create timeless shapes that hold significance. From the natural colors found in stones and metals to the bead practices, I find comfort in the repetitive designs that speak to me and soothe my being.

The Bauhaus was an art movement started in Germany in the 1920s which emphasized design in art, craft, and architecture. The Bauhaus movement has had a huge effect on me and many other artists. It began as a school environment that sought to create serviceable objects of use and beauty, combining craft with fine arts while also adding social relevance to the arts. All mediums could be included with their minimalist and functional sensibilities, and I'm particularly inspired by how they created a creative community with many mediums involved. I often see my life's journey through many mediums tied together with my ideals and core inspirations as an extension of the Bauhaus school. I can feel how its existence and influence in my design repertoire ties me to so many creatives worldwide who are also inspired by the Bauhaus.

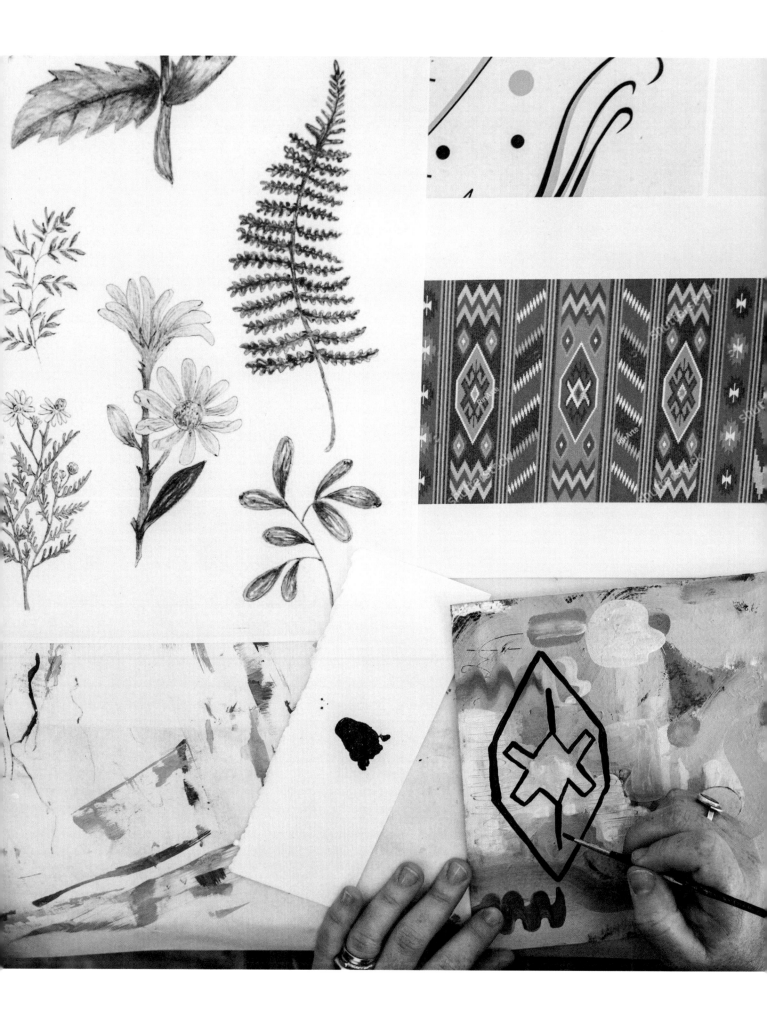

INTEGRATE AND CREATE

Now that your cup is overflowing with artistic inspiration, it's time to integrate all those specific things you love and find ways to weave them into your own unique creations.

If you haven't already spent time looking at and considering what you love about a few pieces of art, this is a great time to do that. Remember, this is not about replication or taking too much from one source. It's about choosing specific things about the artwork that really speak to you and allowing that specific information to serve as a guidepost in your creations.

As you create using this inspiration, continue to weave in your inner explorations, outer explorations, new materials, and the magic of the moment.

Jumping-Off Points

If you're feeling unsure about how to begin, here are a few prompts to get you going:

- Find *one* specific shape in someone else's painting and do a drawing improvisation (See "Drawing Improvisation" ion page 39) to see how your version of the shape can show up in your own painting.

- Try using a new art material that you see in someone's else's work in your own work.

- Find one color you love from someone else's artwork. Do a color pairing study (See "Color Pairing" on page 86) to see how you can work with the color in a way that is all your own.

- Choose three artists or paintings and combine your favorite things about each source along with some of your signature moves to create something new.

- Infuse some of your in-progress paintings with a fresh layer of inspiration derived from something specific you love about a piece of art.

- Look at your answer to the Writing Inquiry question *"An artist or art movement that I would love to learn more about is _____"* and spend some time researching it. When you're ready, create a new painting based on this newfound inspiration.

STUDENT GALLERY

Incorporating Inspiration from Other Artists

This is a sampling of paintings completed by *Fresh Paint E-Course* participants.

TOP ROW, FROM LEFT:
- *Allison Dawrant*
- *Johanna Eager*
- *Debbie Ross*

BOTTOM ROW, FROM LEFT:
- *Elora Penland*
- *Pearl Lawrence*
- *Jolene Peters*

THE END IS JUST ANOTHER BEGINNING

YOU MADE IT, LOVE! You have arrived at the end of this book, but we sincerely hope that you feel poised at the beginning of something new and invigorating, a path of possibilities laid out before you.

If you've completed or even just begun your one hundred paintings, congratulations! That, in and of itself, is something to celebrate as starting is often the hardest part. If you're reading this book all the way through *before* you begin, we hope you feel the bubbling excitement of what's to come. We also want to remind you that the intention of this practice is not to finish one hundred little masterpieces. Rather, we're here to deepen and develop our style. As promised, this book is not a tidy, step-by-step manual whisking you effortlessly towards your great masterpiece. In many ways, it's the opposite of that.

Within these pages, we asked you to dig deep and to take an honest and inquisitive look at who you've always been and who you are becoming. We encouraged you to slow way down and notice the uniqueness of the world that surrounds you. We offered you a buffet of art techniques, materials, and "ways in." Then, we lovingly told you to get to work.

Within each prompt and within each of your one hundred paintings, there are infinite questions to ask and choices to make: *"What emerges when I get quiet enough to hear?"*, *"What do I connect with in my cultural lineage?"*, *"What shapes feel important enough to harvest and incorporate into my paintings?"*, *"What layers should I cover up?"*, *"What colors make my heart sing?"*, and *"What materials feel like a breakthrough in and of themselves?"*

And the list goes on . . .

In many ways, this practice of discovering and developing a unique art style is really a practice in trusting yourself to make these decisions for yourself, one after the next. It's about standing in your personal truths and declaring them loud and clear on your paper. It's about beginning again and again, each time with a little more skill, information, and experience than you had the day before.

We know climbing this creative mountain of making one hundred paintings is no small feat. It takes dedication, patience, curiosity, and let's face it, a whole lot of *time*. It's likely you'll get stuck along the way, perhaps many times over. And that's okay. In fact, your biggest breakthroughs probably live right on the other side of your greatest moments of frustration. You just have to keep going in order to find them.

What's Next?

We hope that all this hard work pays off in the form of beautiful, well-earned, and unexpected gifts and that new space for discoveries open up by your willingness to show up and do this work. We also hope you will stay receptive and curious to what unfolds next.

For Lynx, an invitation to paint a large mural in a prominent retail store came shortly after she finished her own one hundred paintings. By cultivating the creative confidence and new ideas in her small paintings, she was able to say a big YES to this project. That one mural has now turned into three murals!

Flora's breakthroughs came in the form of discovering new color palettes, fresh imagery, and unique compositions that translated directly into her larger work on canvas. She was also happy to be able to offer more affordably priced original paintings in her latest art show.

How will *you* take the most supportive and inspiring aspects of what you discovered here and integrate and create them into your own artistic life?

We suggest paying close attention to what feels the most alive in your art-making practice moving forward. Even if the aliveness is subtle, follow it. Get curious. Hold it tenderly and notice where it's leading you. Remember, you do not have to know everything that's coming next. Just follow your next craving, like you do with color.

Maybe you'll hang all your paintings on one wall at one time and create an installation? Maybe you'll take *one* thing you discovered from the course and create a whole new body of work inspired by that one thing? Maybe you'll scan your

paintings and create a book of art and poetry? Maybe you'll auction them off and raise money for one of your favorite causes? Maybe you'll paint one hundred *more* small paintings!?

There is no limit to what's possible when you honor your unique voice, stay true to your lived experience, and create with a dedicated heart. Your desire is there. Now trust, stay awake, be gentle, keep expanding and exploring . . . and stay the course.

The world needs what you have to share.

Your time is now.

RESOURCES

Gathering Inspiration from Your Internal Landscape

- Insight Timer is a free app full of meditations and resources (www.insighttimer.com)

- 23 And ME is a fabulous way to find out about your ancestral lineage (www.23andme.com)

- Tara Brach is a Buddist teacher whose podcast and book, *Radical Acceptance*, have been a source of great inspiration for exploring our inner landscape.

Gathering Inspiration from Your External Landscape

- Google image search is a great research tool for sourcing new imagery.

- Instagram and Pinterest are also places to source inspiration. Search specific hashtags on Instagram to narrow your results and be sure to check out #freshpaintcourse. On Pinterest, you can organize and archive your inspirations by creating themed "boards" to revisit later on.

- Our favorite drawing tools for sketching on the go are: Microns, Sharpies, and Faber-Castell markers.

Expansion with New Materials

- We love to shop at our local art supply stores for paint, brushes and paper. In Portland, Oregon, we love Collage (www.collagepdx.com) and Artist and Craftsman (www.artistcraftsman.com)

- For online art supplies, we love Blick Art Materials (www.dickblick.com)

- For a wide variety of craft materials, we love Etsy Marketplace

- Our favorite acrylic paint: Golden Acrylic Paint: (www.goldenpaints.com)

- Our favorite foam brushes: Poly-Brush (www.jenmfg.com)

For The Love of Color

- Looking for color inspiration? Check out books or Google image search things like textile art from around the world, floral arrangements, tropical birds and fish, and stained glass design.

- Paint color chips found in hardware stores are a fun way to expand and explore new color combinations.

- *The Secret Lives of Color* by Kassia St. Clair is a beautiful book outlining the history of colors and the vivid stories behind them.

Gathering Inspiration
From Other Artists

- We love Julia Cameron's suggestion of taking yourself on regular "Artist Dates," and we especially love museum dates. Some of our favorites are the Guggenheim, The Seattle Art Museum, The Museum of Contemporary Art Chicago, the Stedlijk Museum in Amsterdam, and Frida Kahlo's Casa Azul.

- *New American Paintings* is a fantastic periodical that features the work of emerging artists working in a wide range of styles. (www.newamericanpaintings.com)

Some of our favorite Instagram accounts to follow are @tesseraartscollective, @piece_with_artist, @amplifierart, @thejealouscurator, @supportblackart

ACKNOWLEDGMENTS

TO THE LONG LINE OF INNOVATORS, rule-breakers, and creative visionaries who have courageously shared their truest, weirdest, most wonderful selves with the world. Thank you for giving us permission and showing us the way.

To all the wonderful people we've had the pleasure of meeting in person and sharing this work with online in the Fresh Paint E-Course. Thank you for your open hearts, curious minds, and commitment to finding your truth. We're rooting for you!

To our creative community for the deep weave of support, inspiration, and collaboration.

To Tina Grecchi for all manner of behind the scenes wizardry.

To Anna Caitlin for the gorgeous photography.

To our wonderful team at Quarto for helping us bring this book to life.

And to you, dear *Fresh Paint* reader. Thank you for following the whispers that led you to pick up this book. We hope our guidance leads you back to parts of yourself that have always been there waiting to be remembered.

We are so grateful.

ABOUT THE AUTHORS

FLORA BOWLEY AND LYNZEE LYNX have been painting collaboratively and facilitating creative retreats since 2012. They share a deep mutual love for authentic expression, both in their artwork and in their lives. They consider themselves a "visual band," lovingly known as Teal Diamond.

Lynx is a mama of two and enjoys creating in many mediums, including paint, beads, metal, and fabric. She's passionate about ecological preservation, personal style, embodiment, and cultural art practices. Flora is a painter, creative pioneer, and author of three other books, *The Art of Aliveness, Brave Intuitive Painting, and Creative Revolution*. Her soulful approach to the creative process has inspired a holistic movement in the intuitive art world.

Flora and Lynx's combined styles and lifelong dedication to art, truth, service, laughter, and healing create a dynamic and joy-filled space to explore the deeper conversations of authentic living and personal style.

INDEX